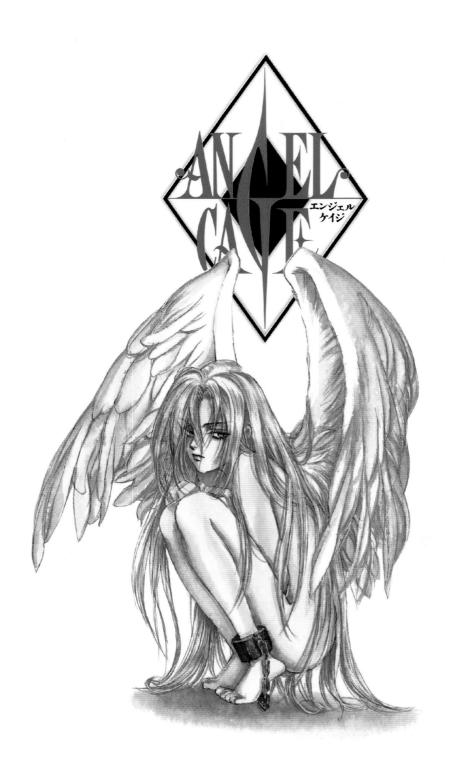

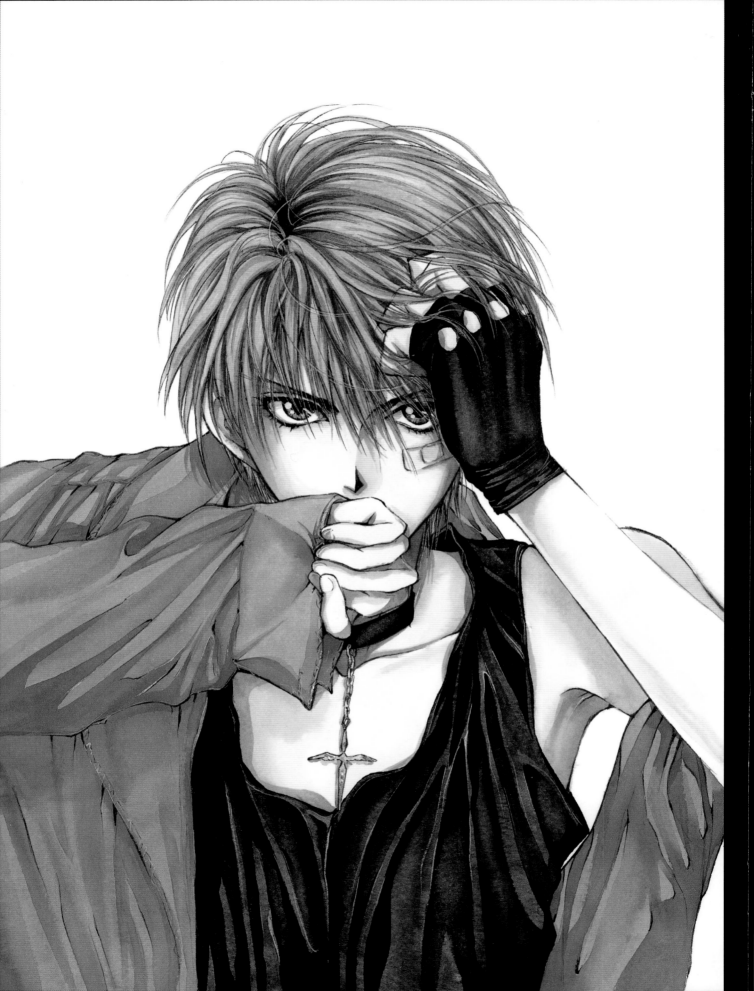

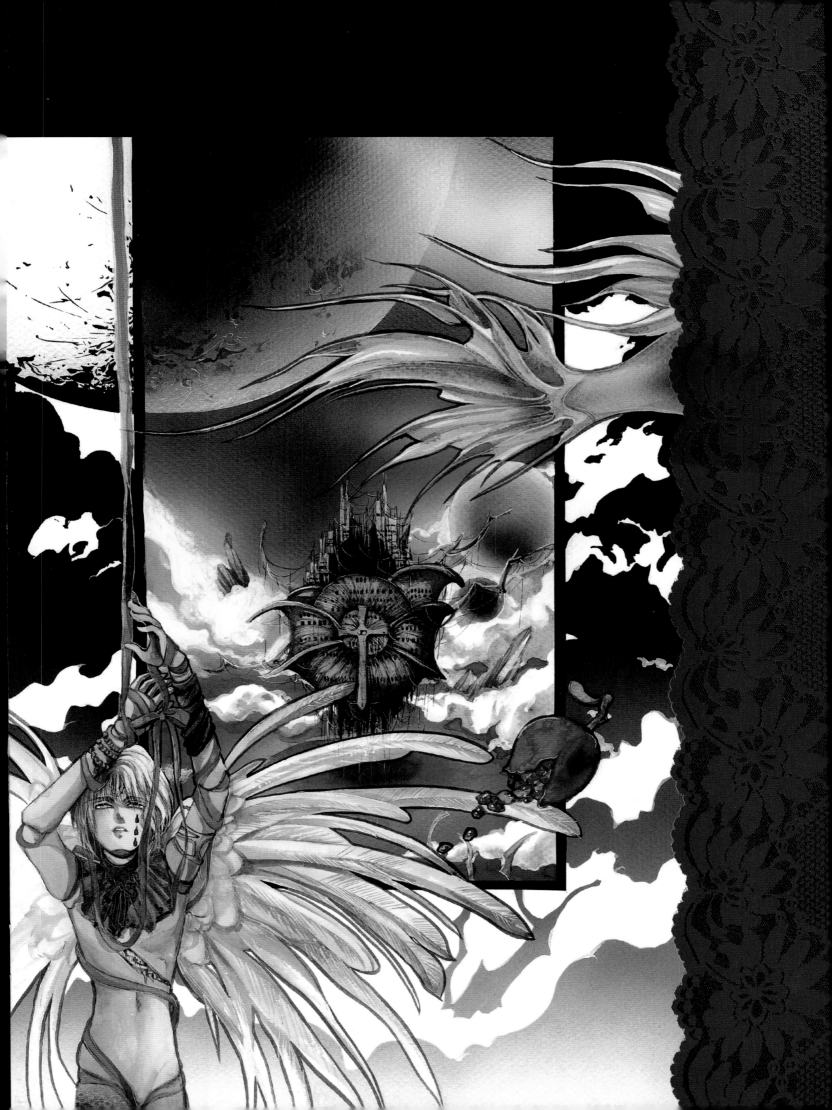

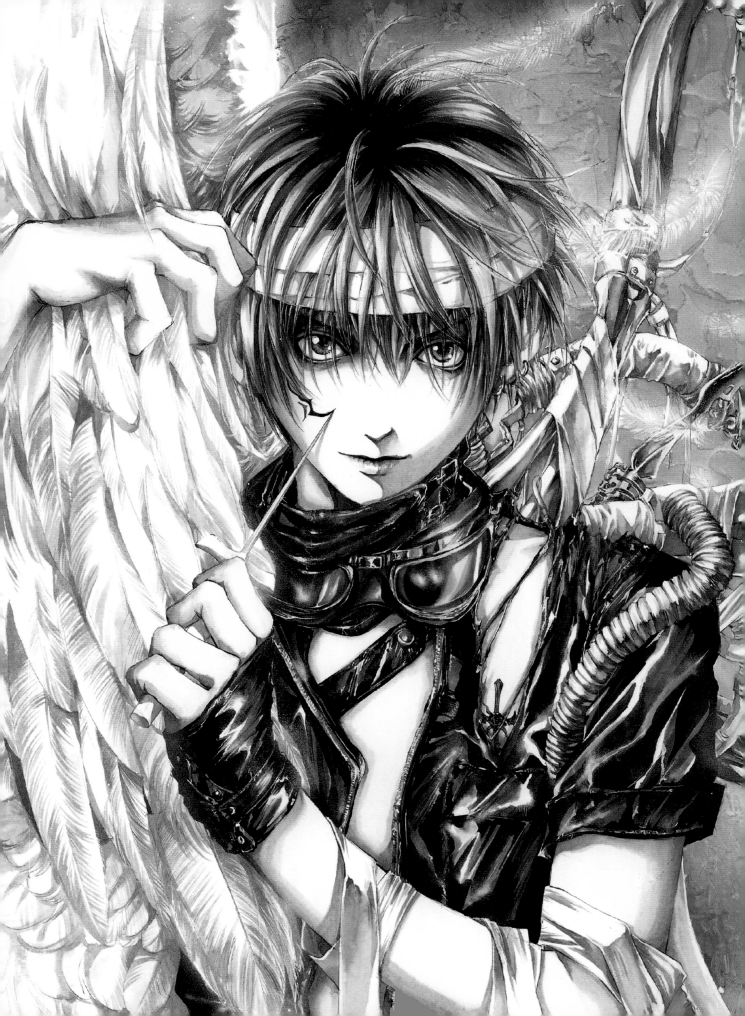

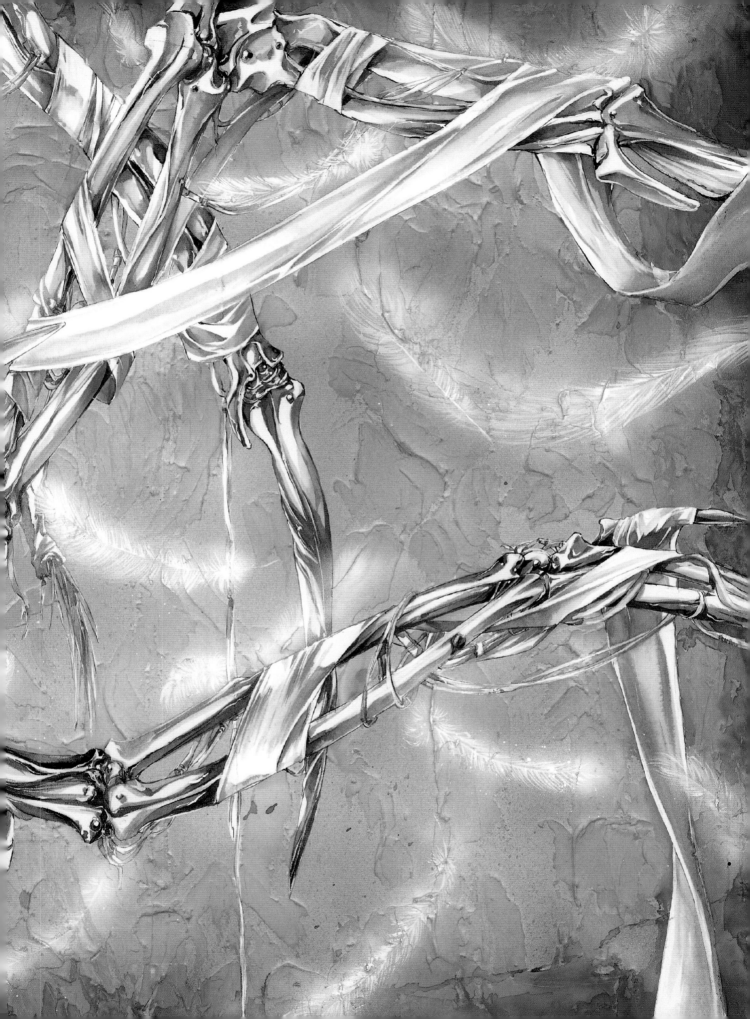

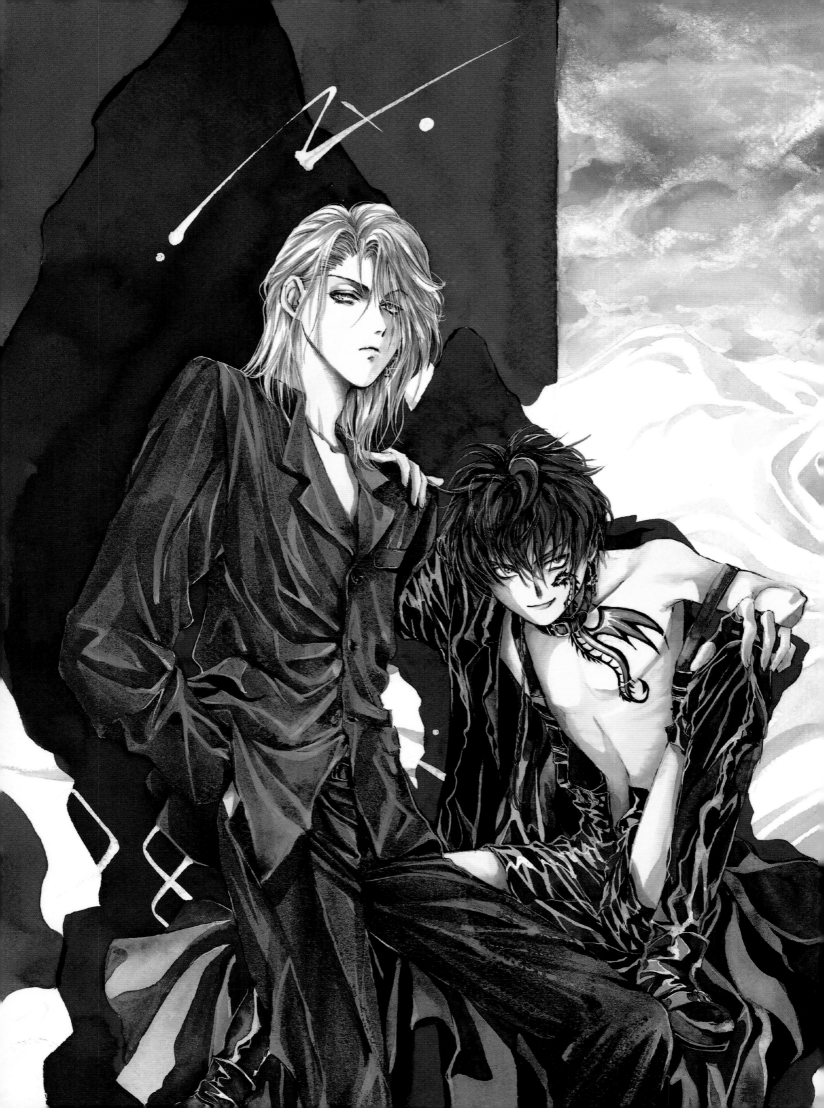

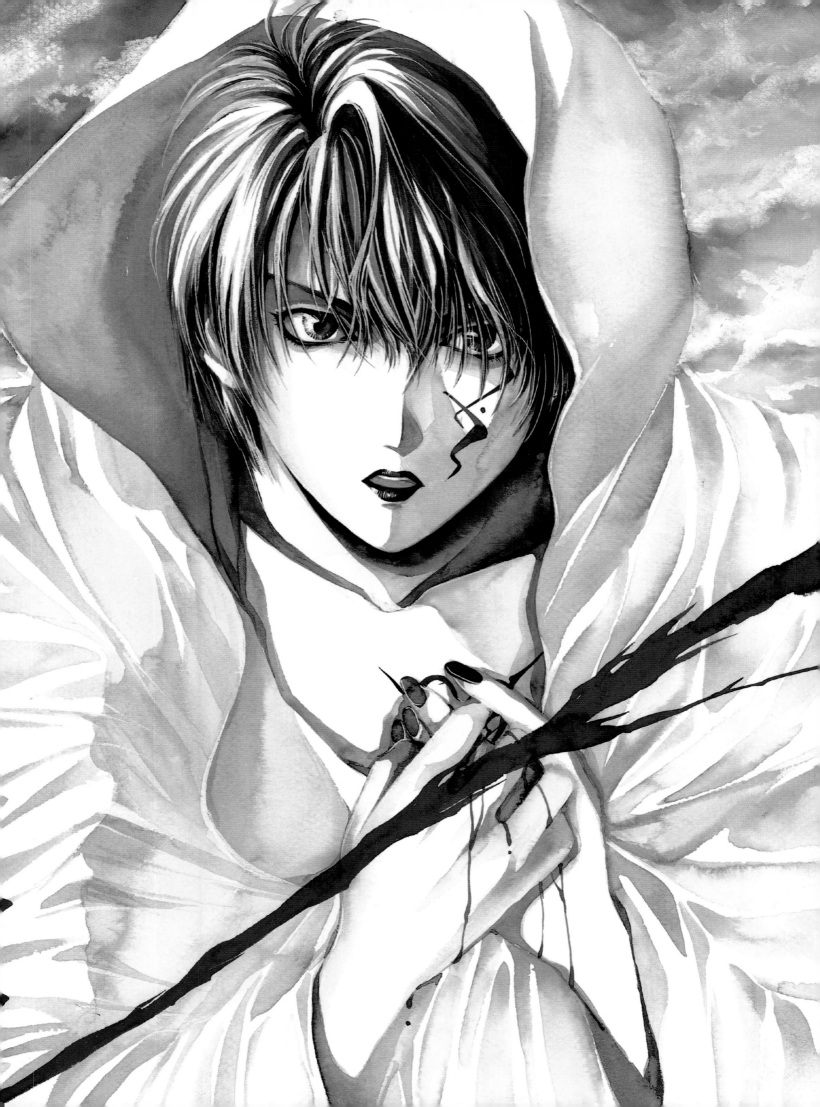

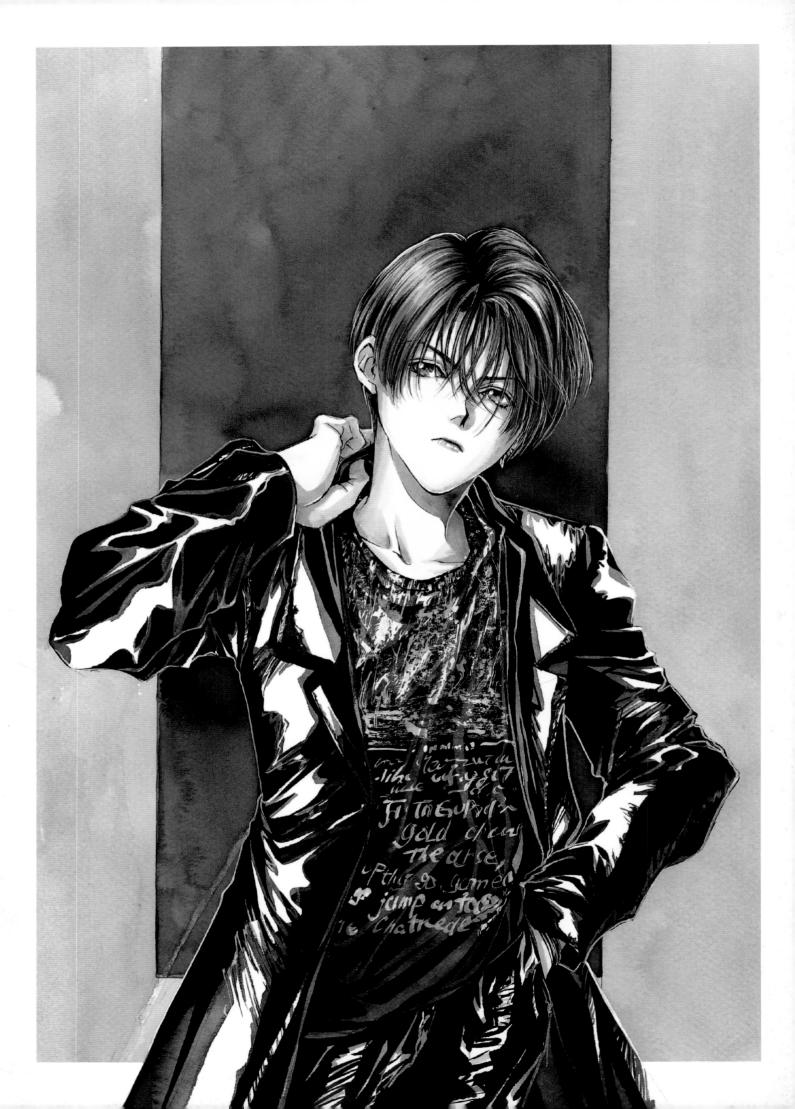

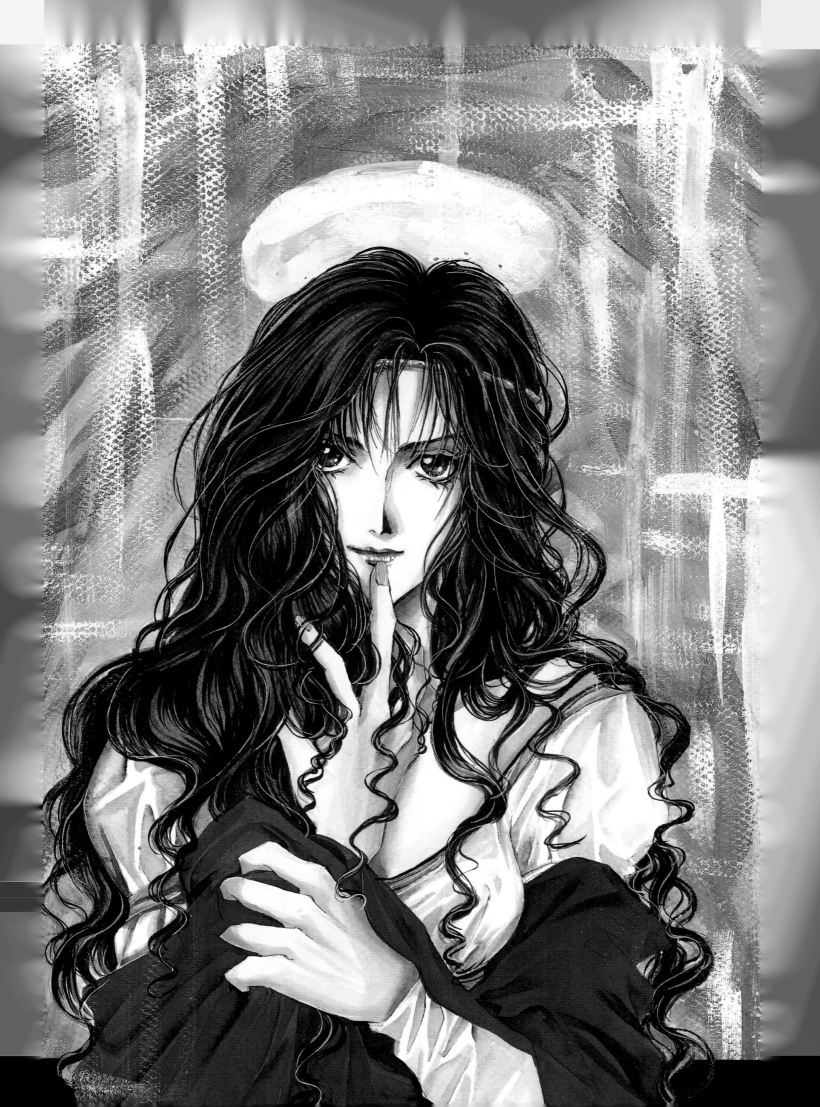

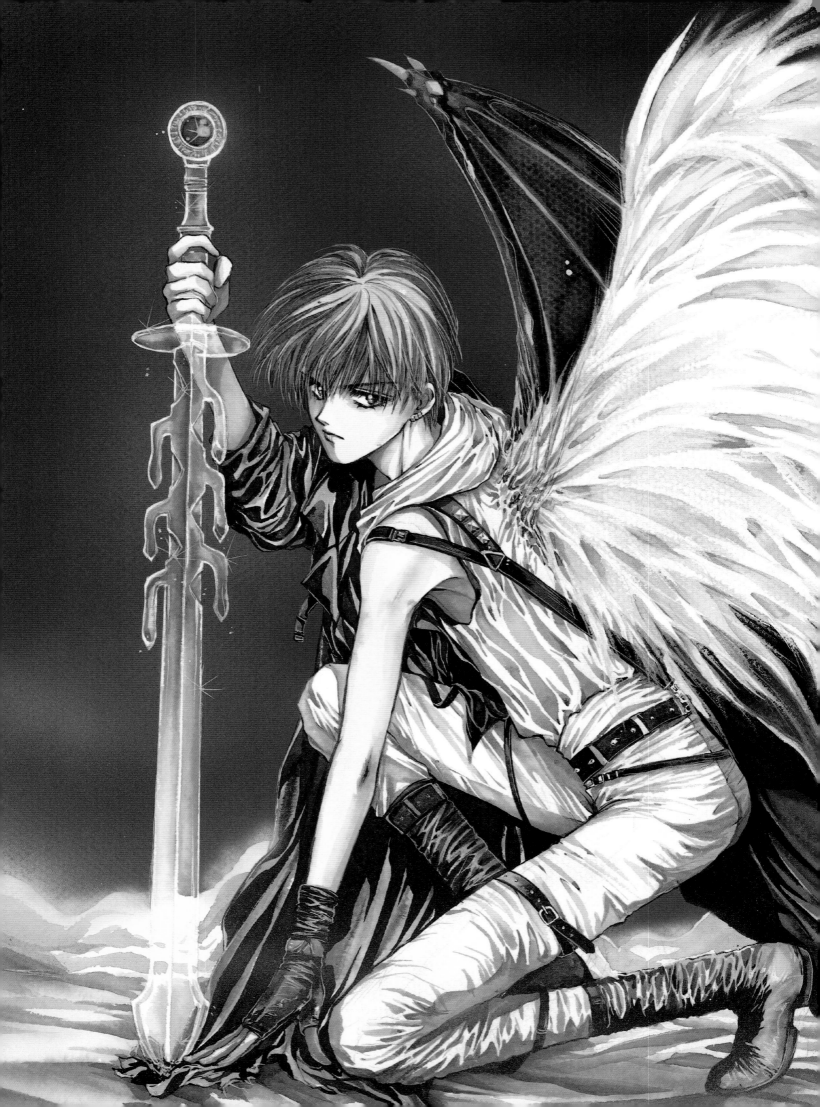

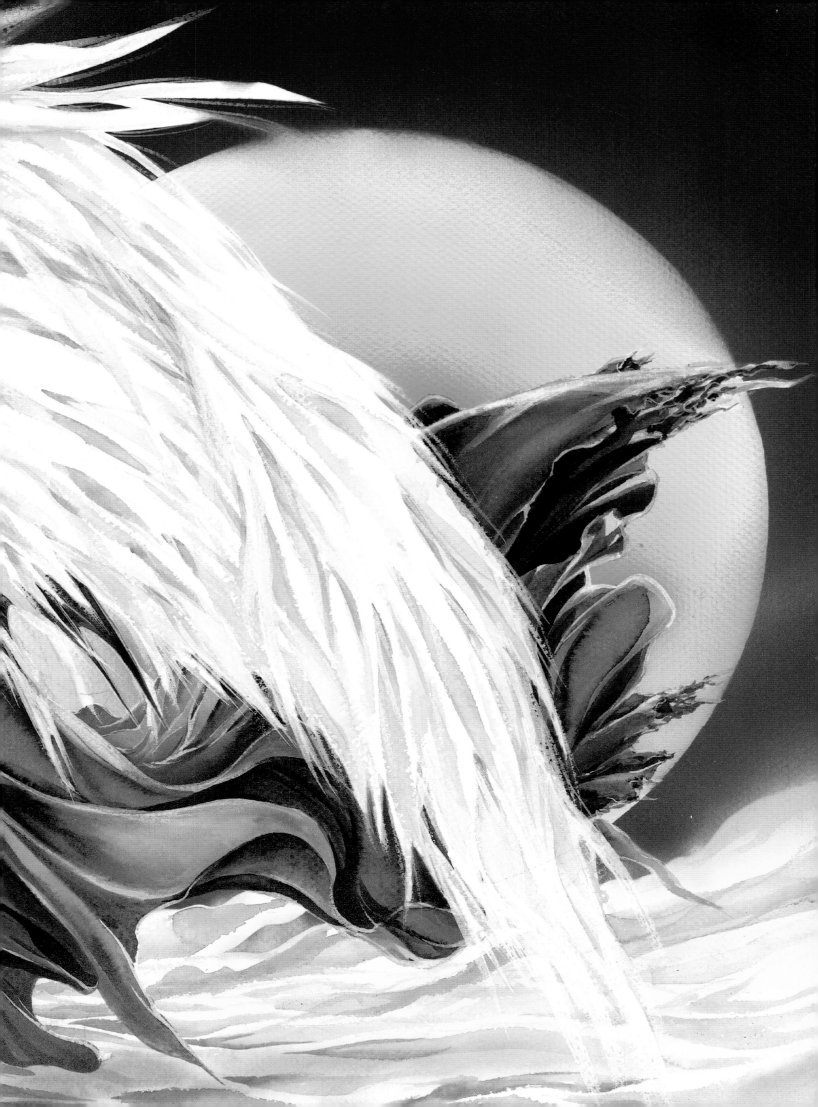

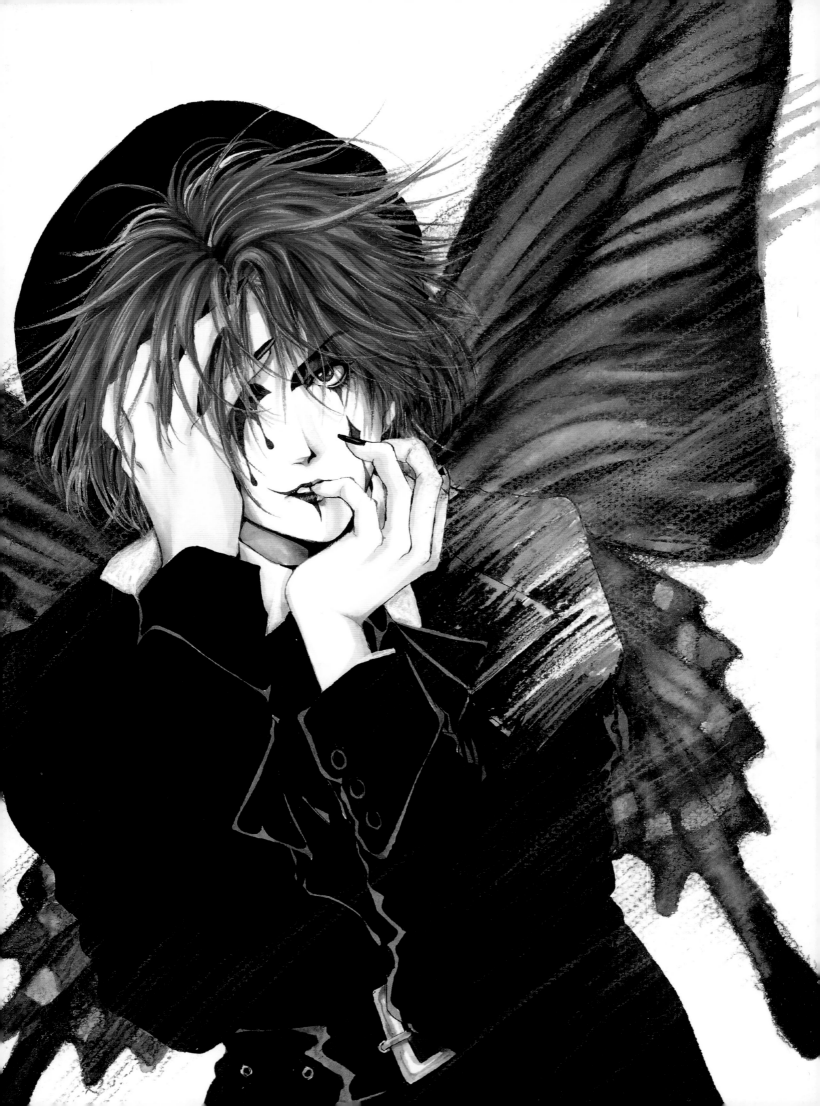

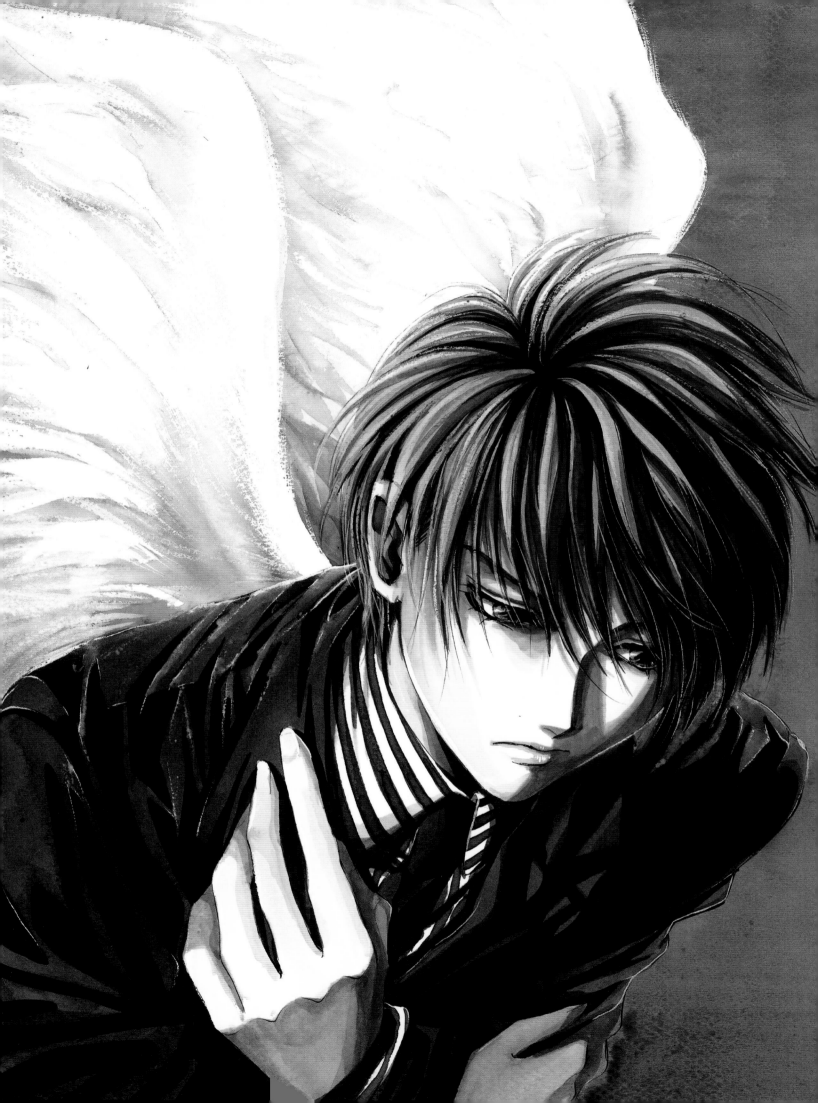

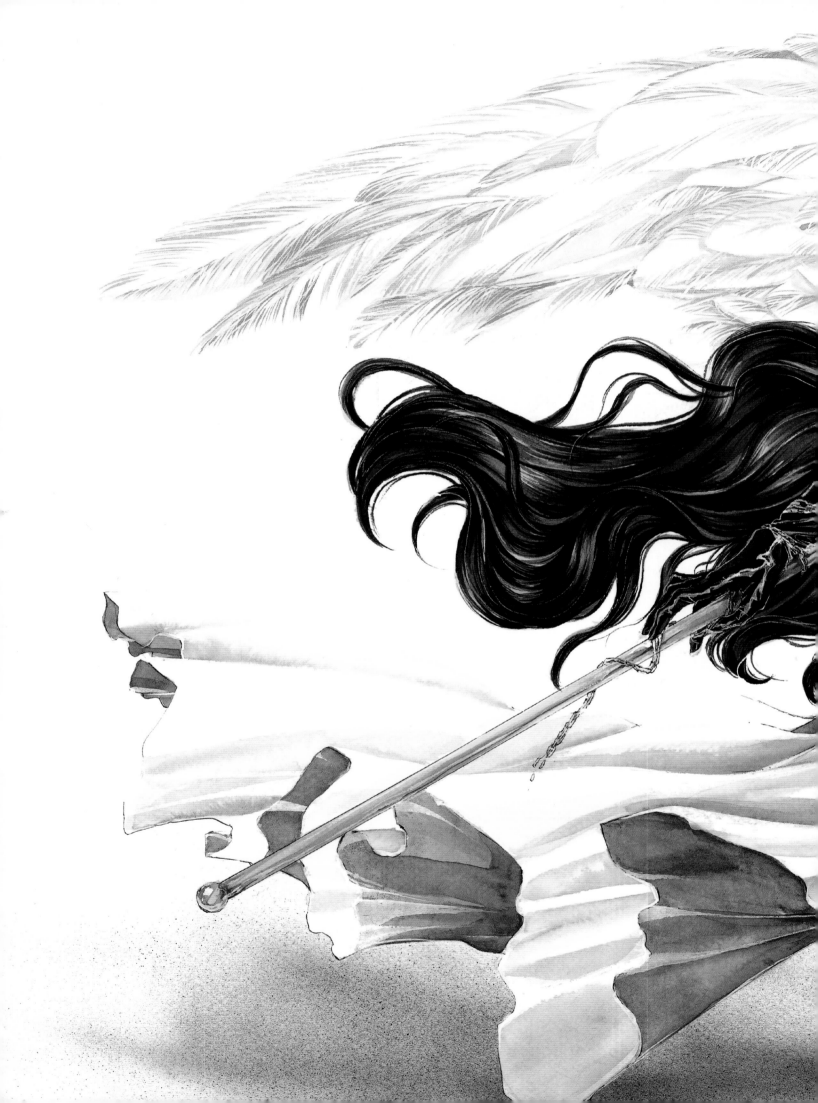

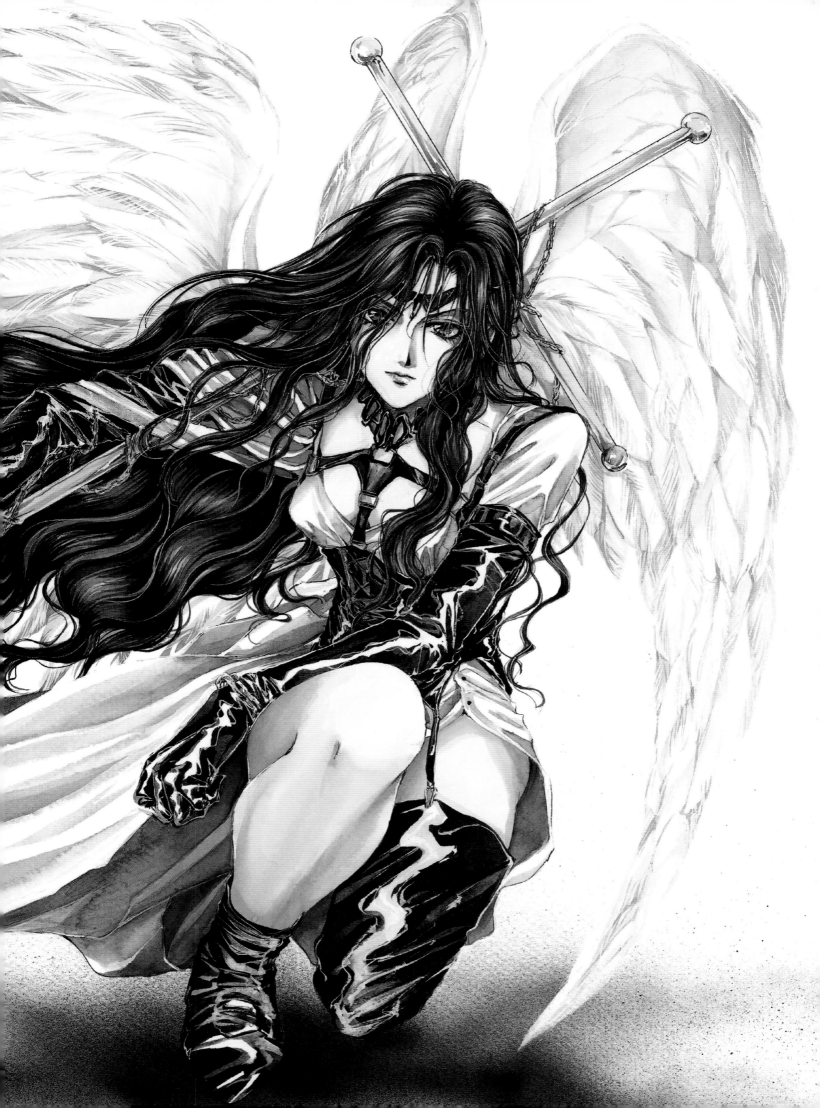

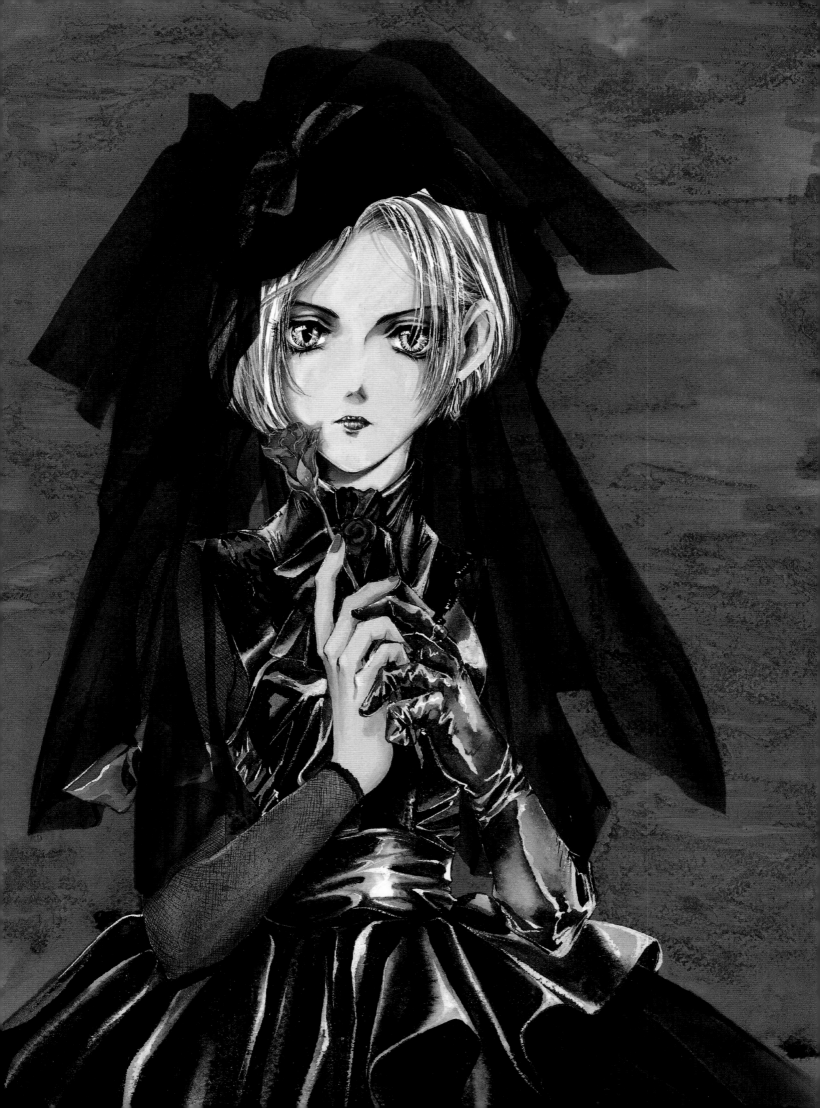

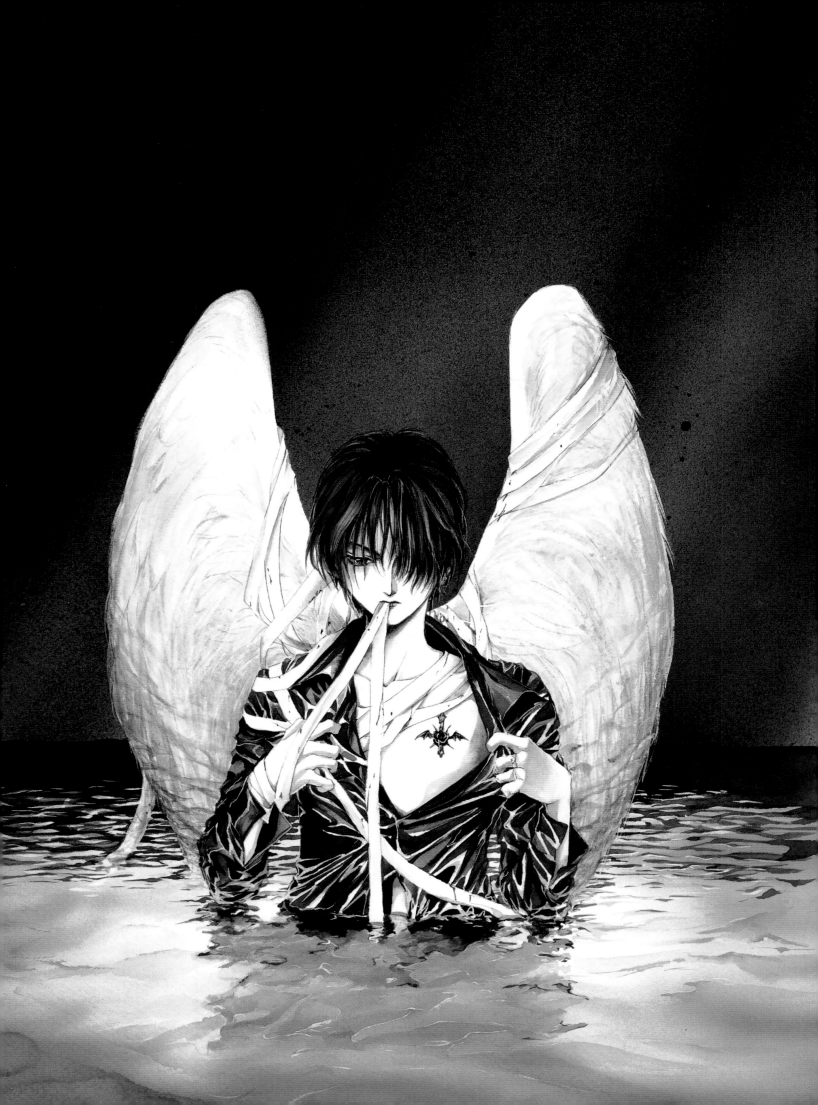

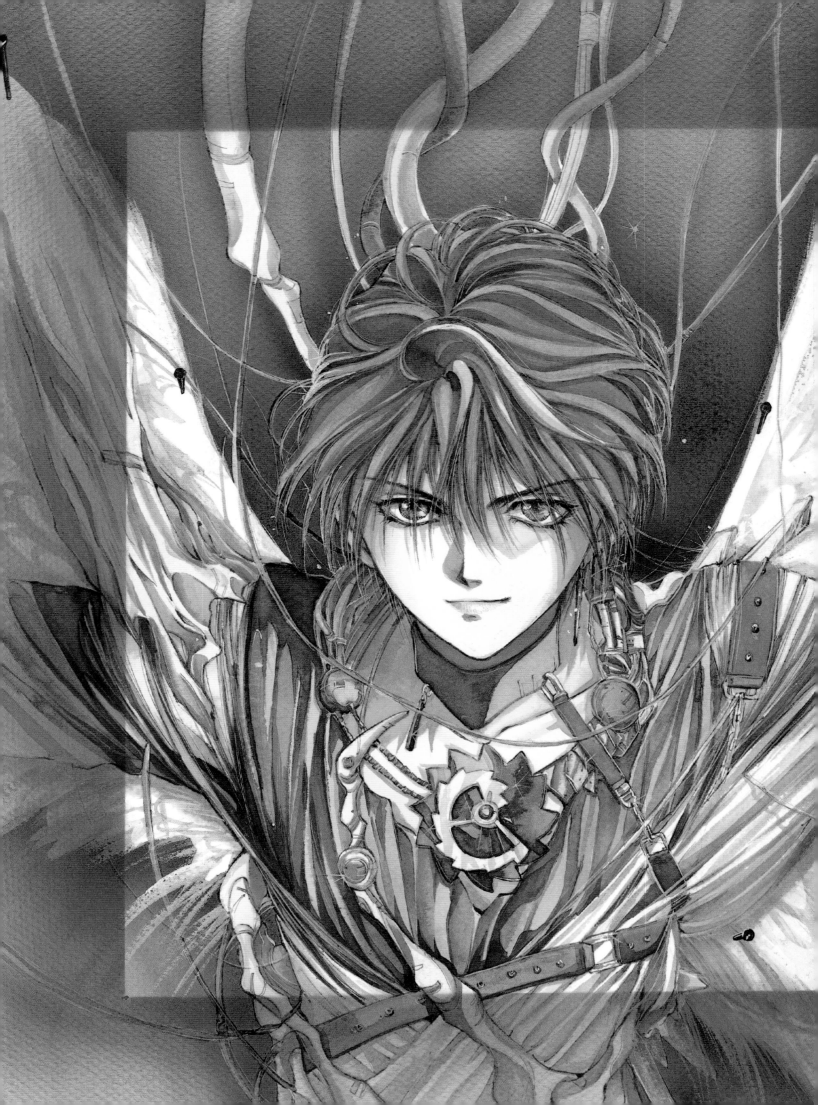

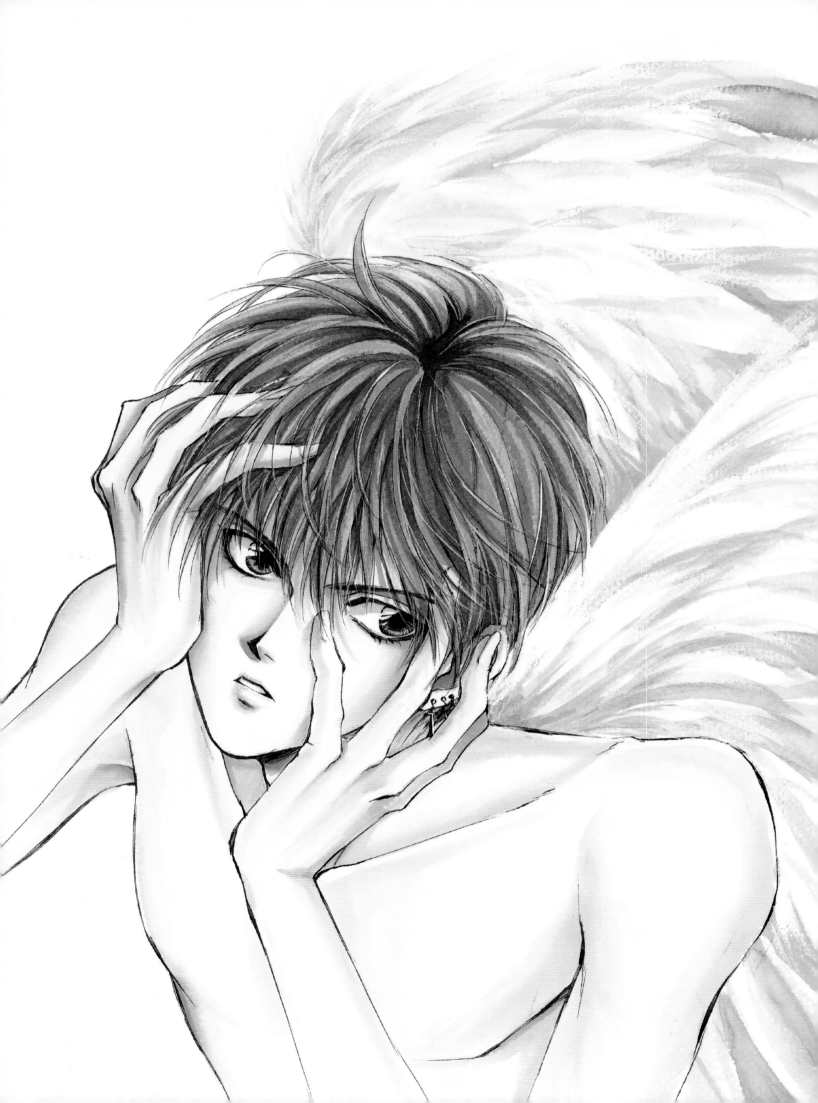

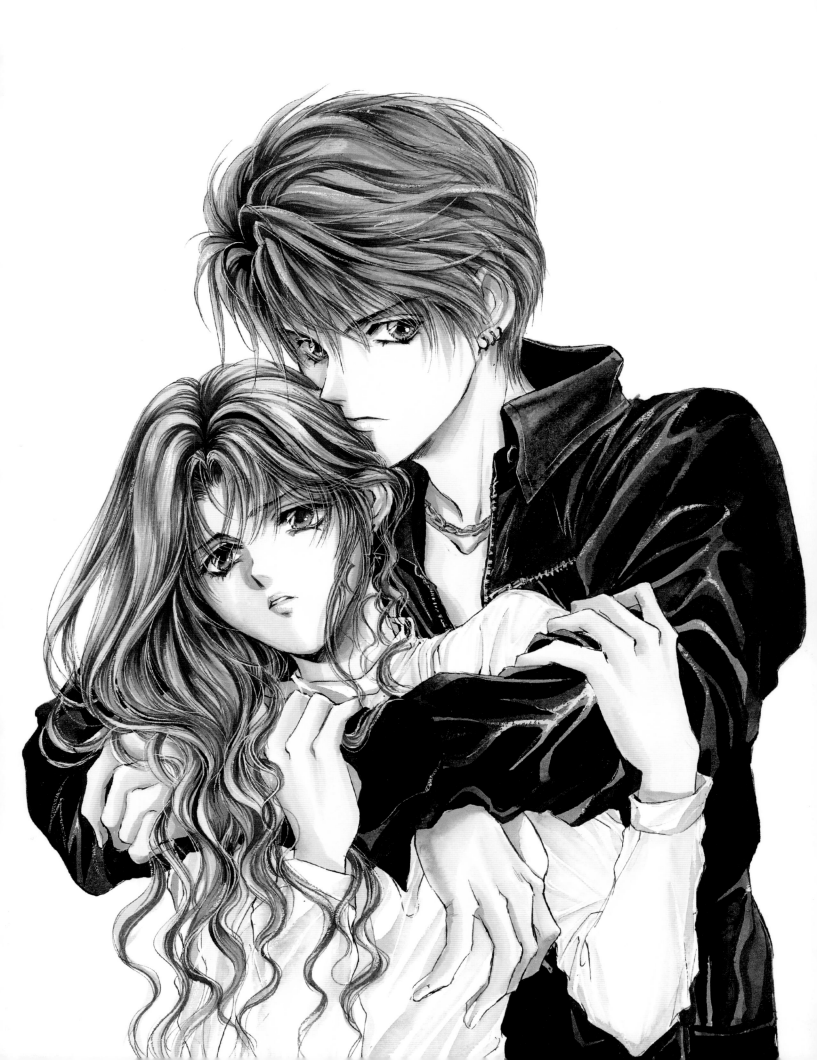

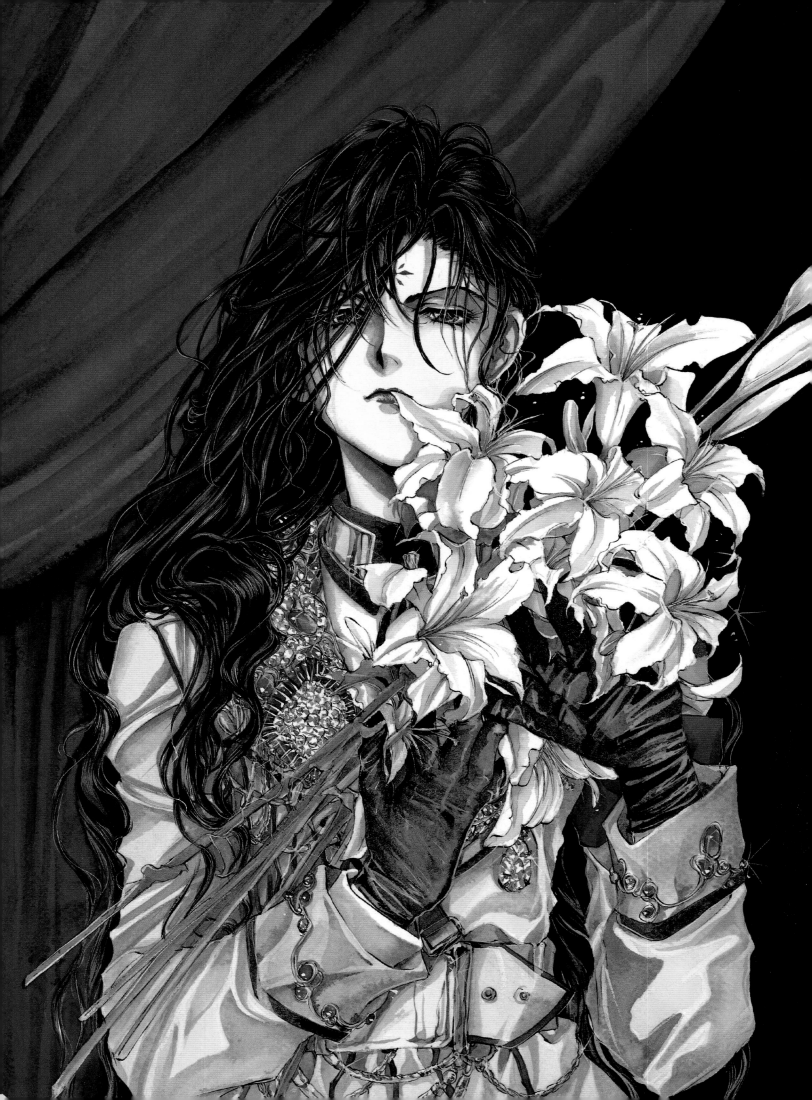

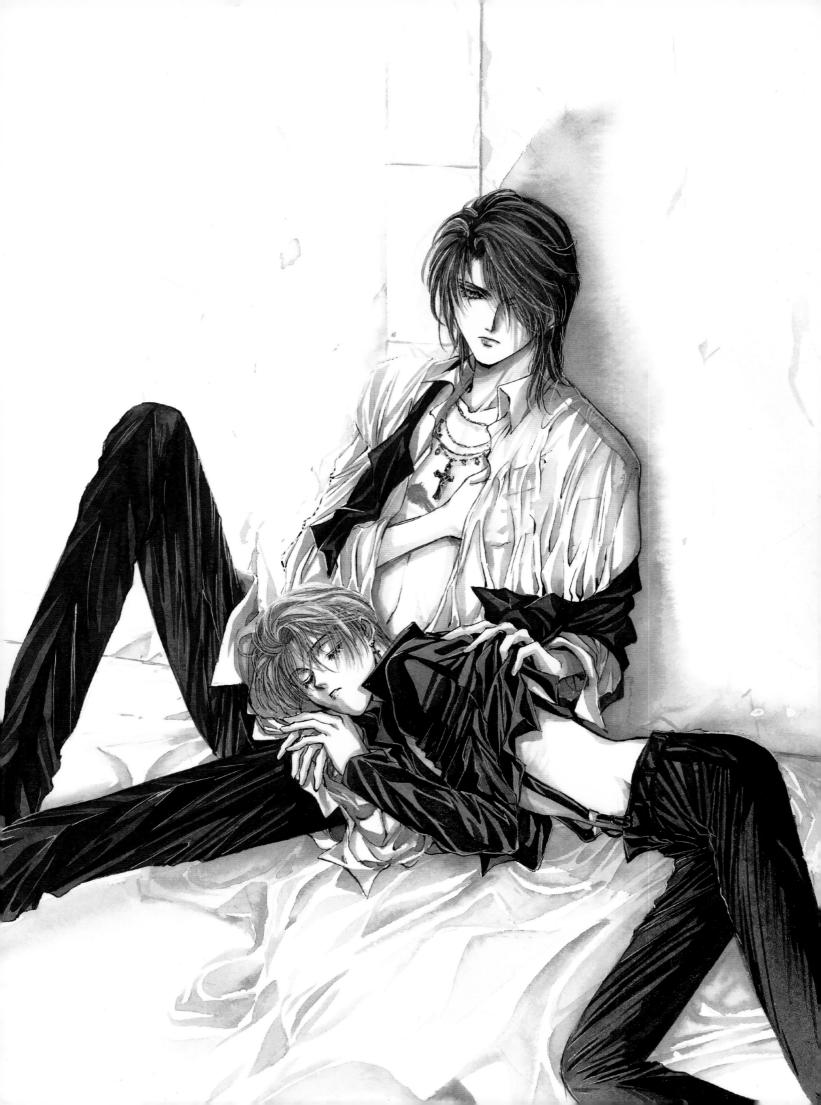

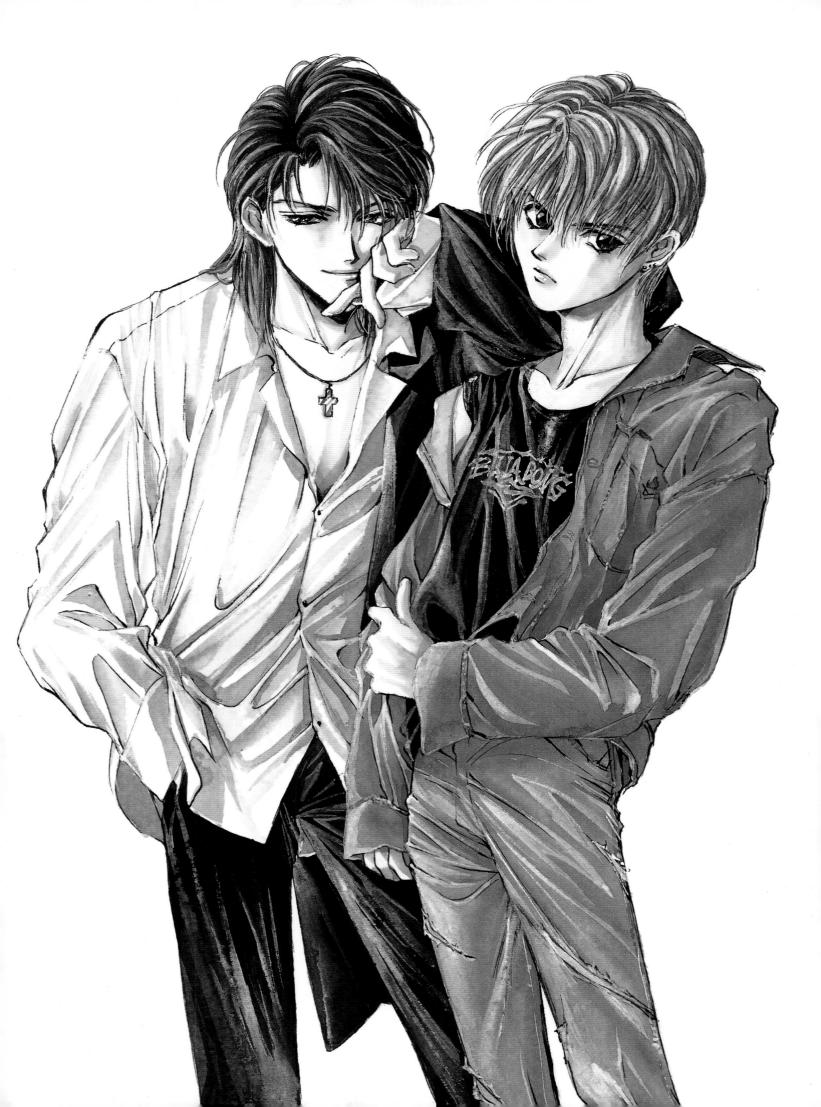

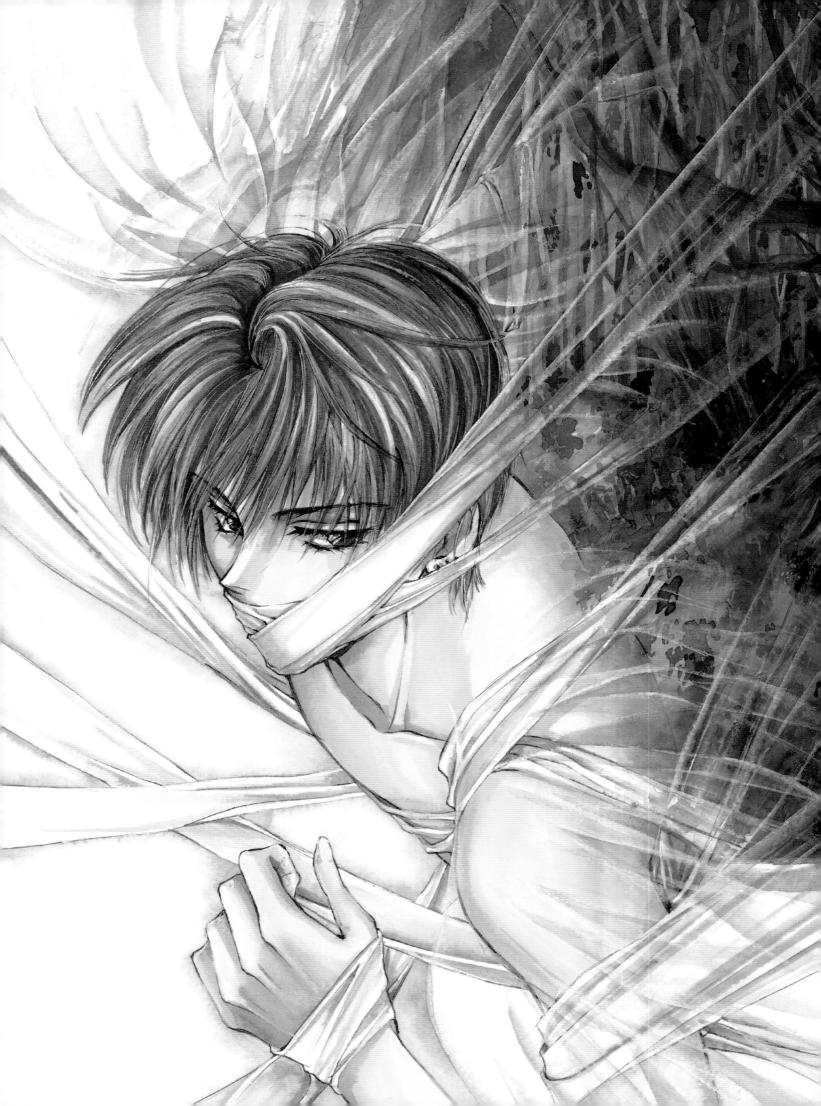

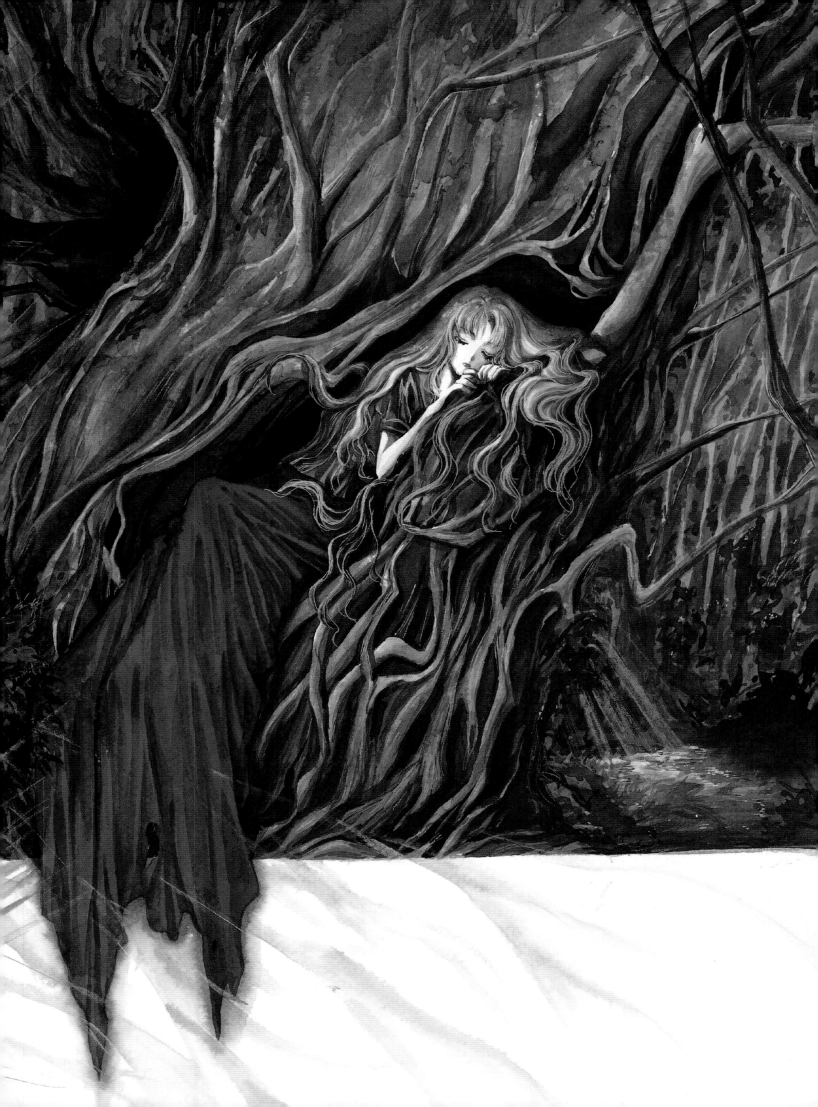

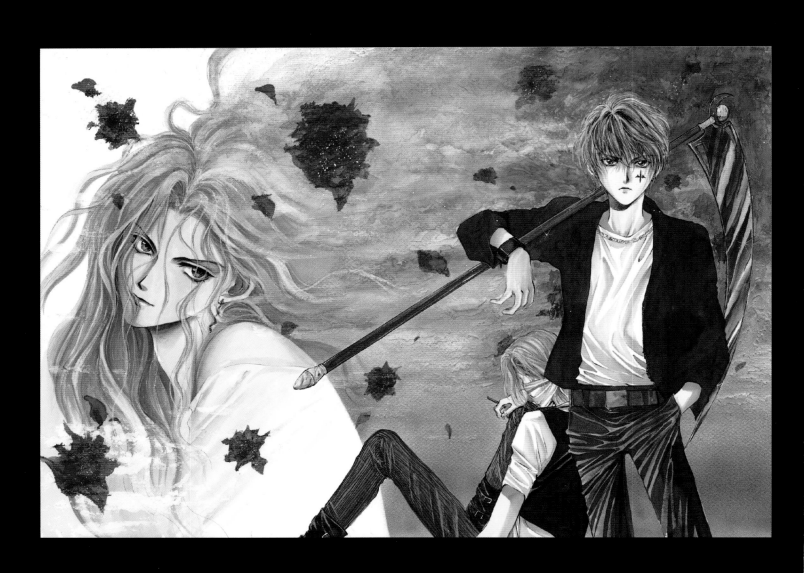

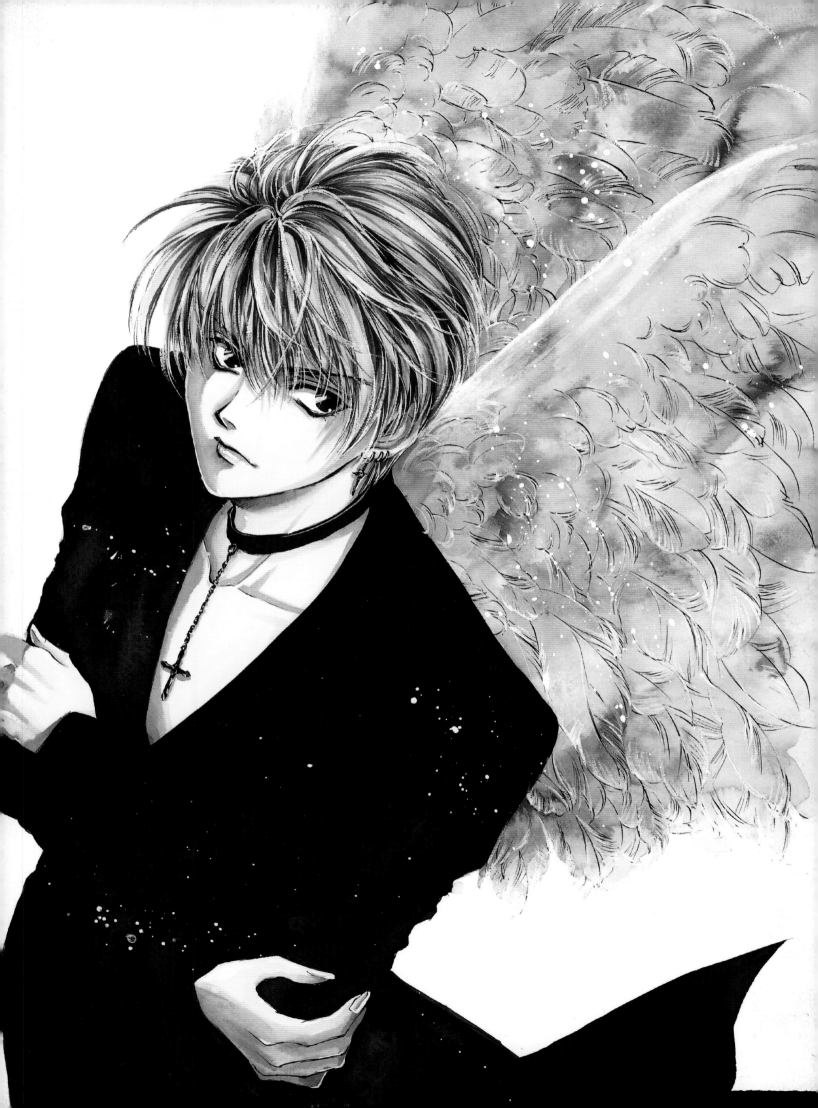

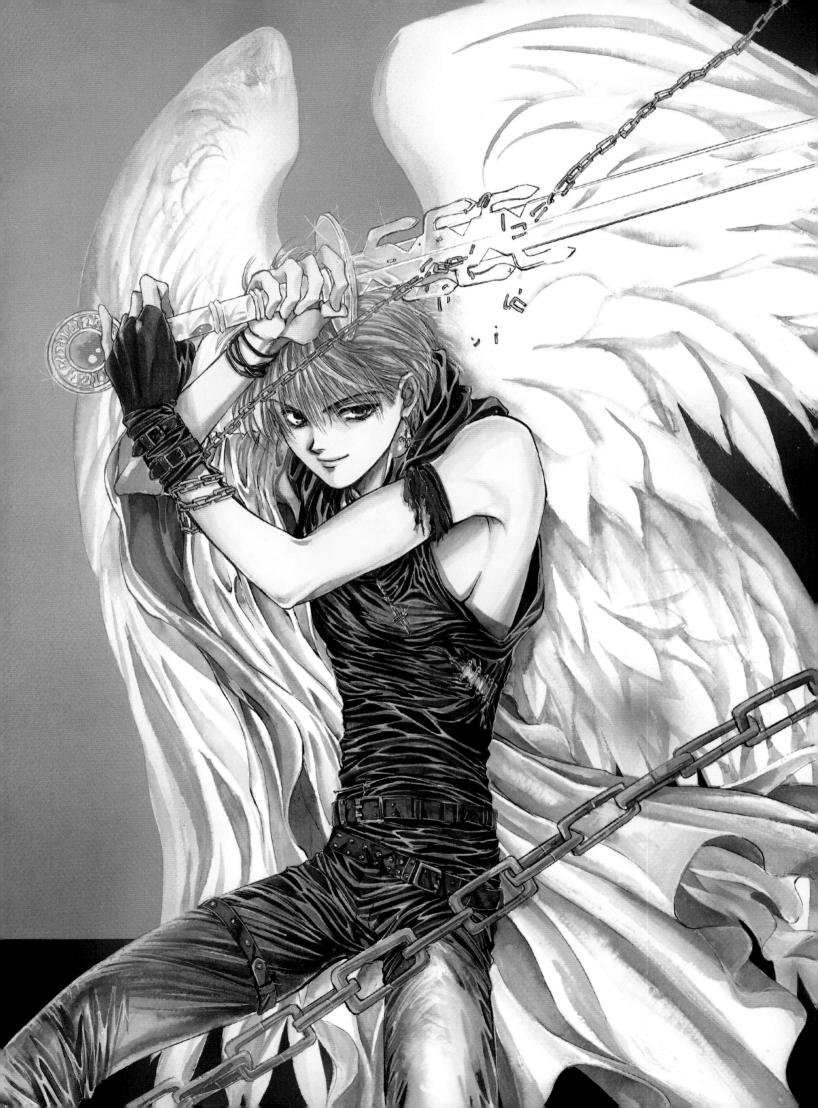

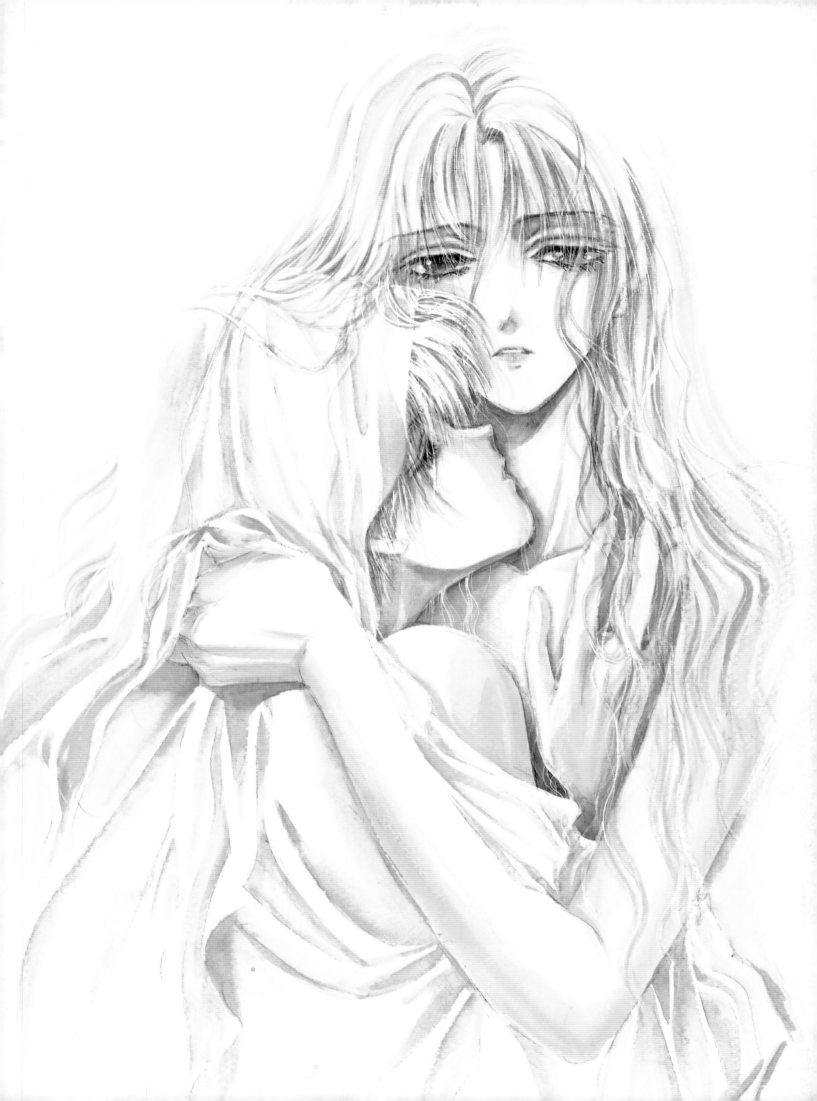

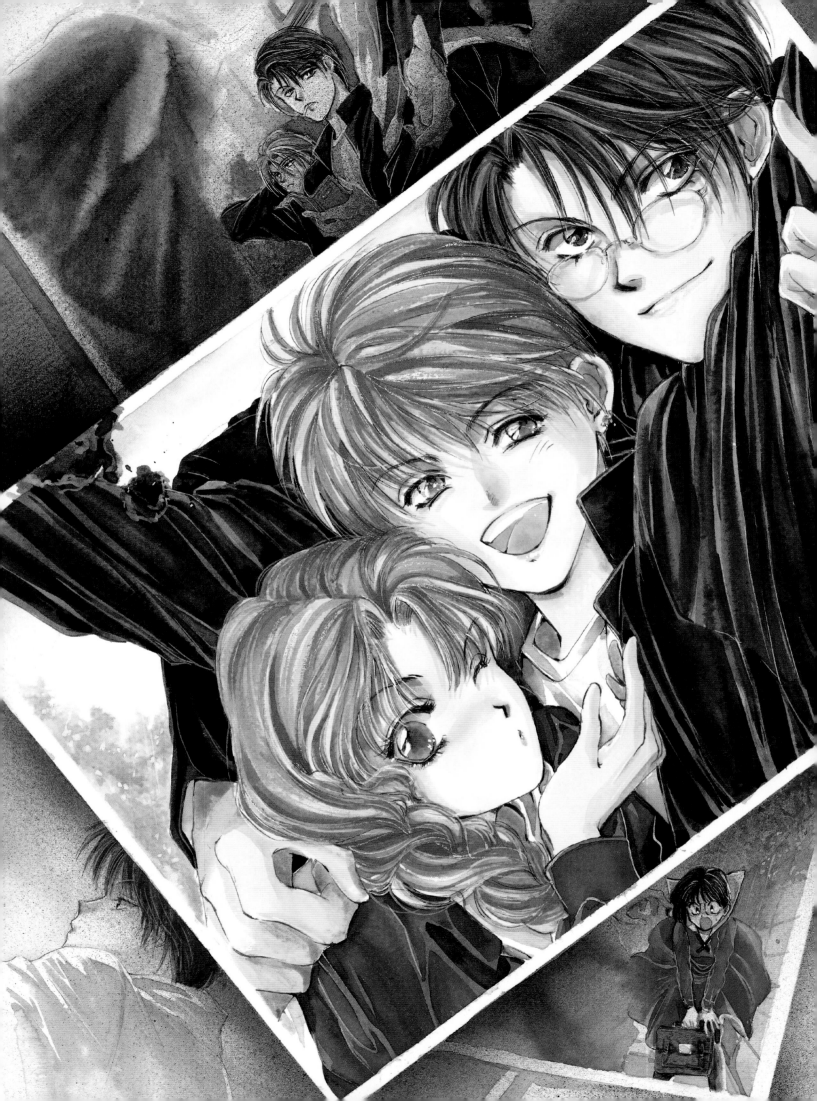

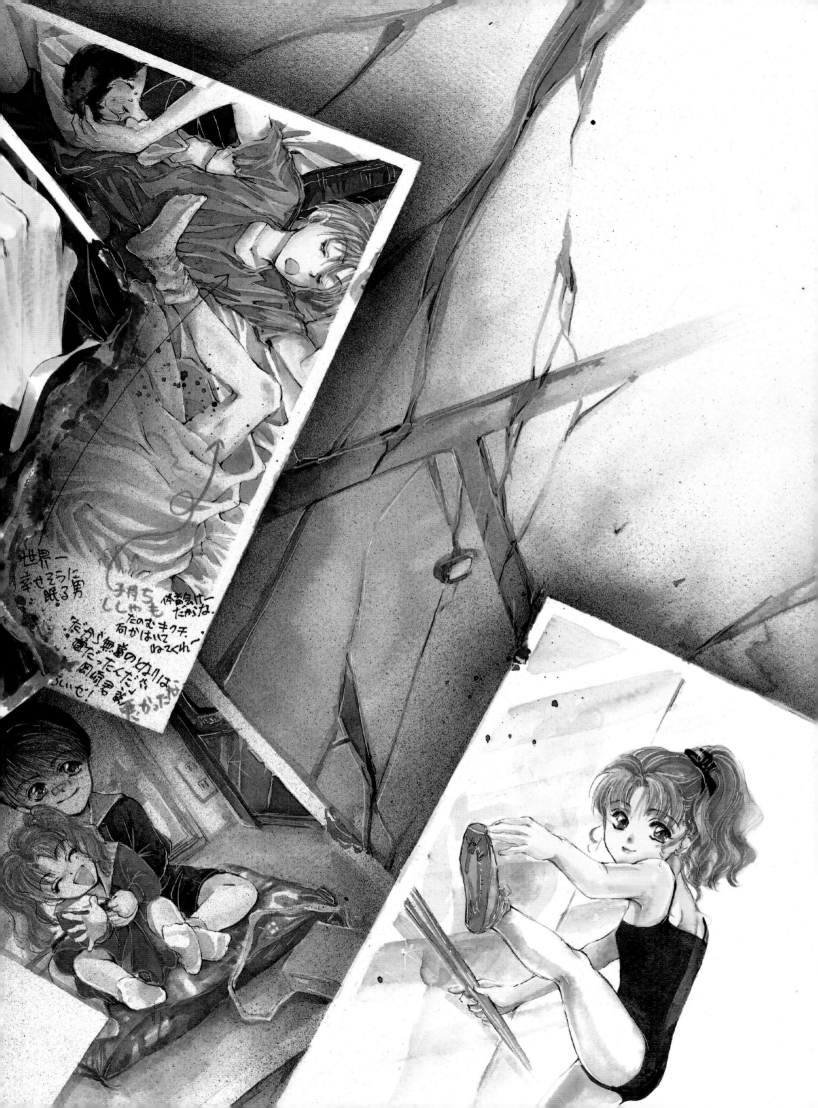

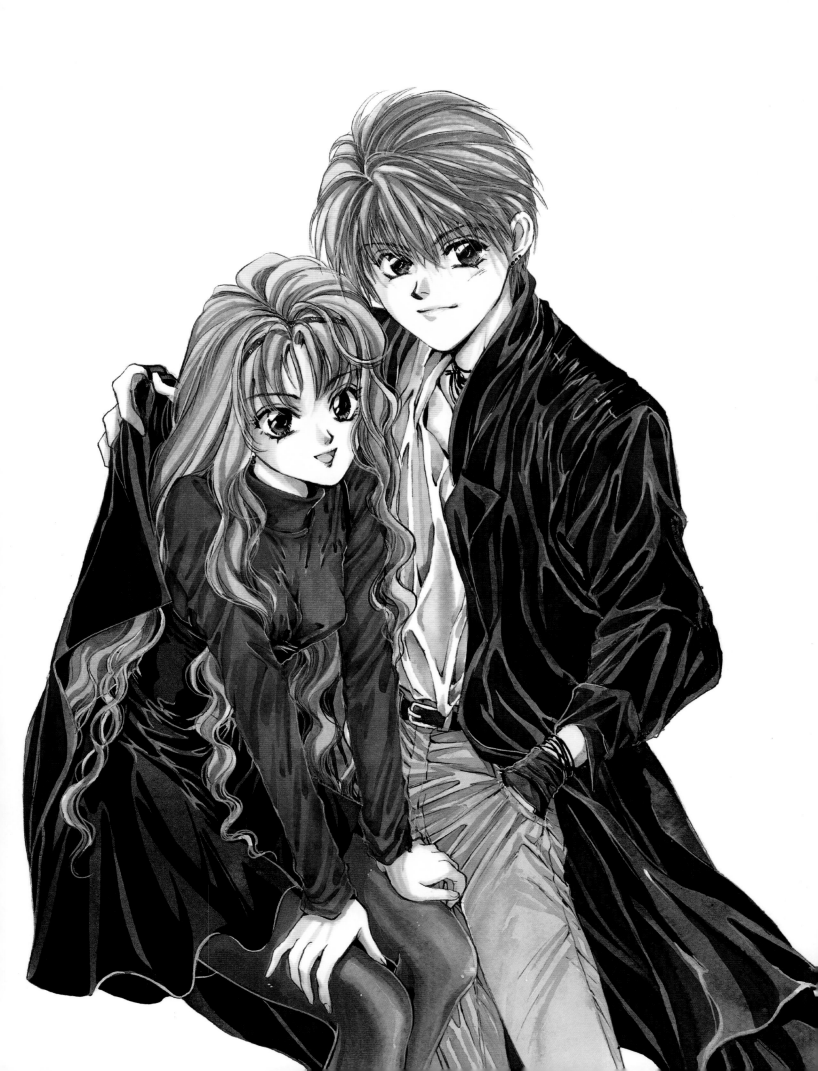

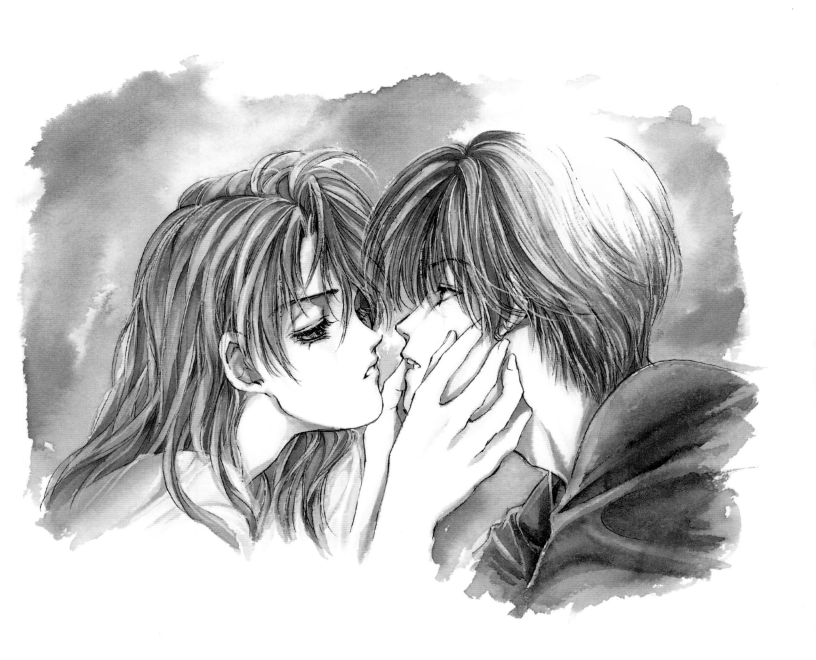

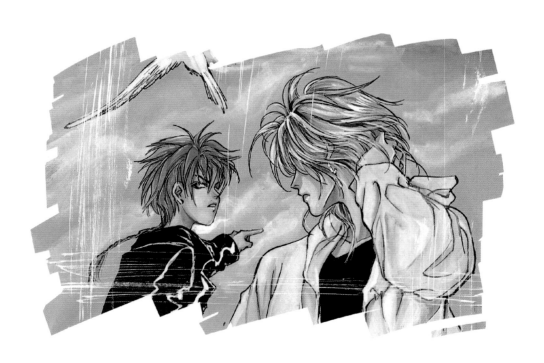

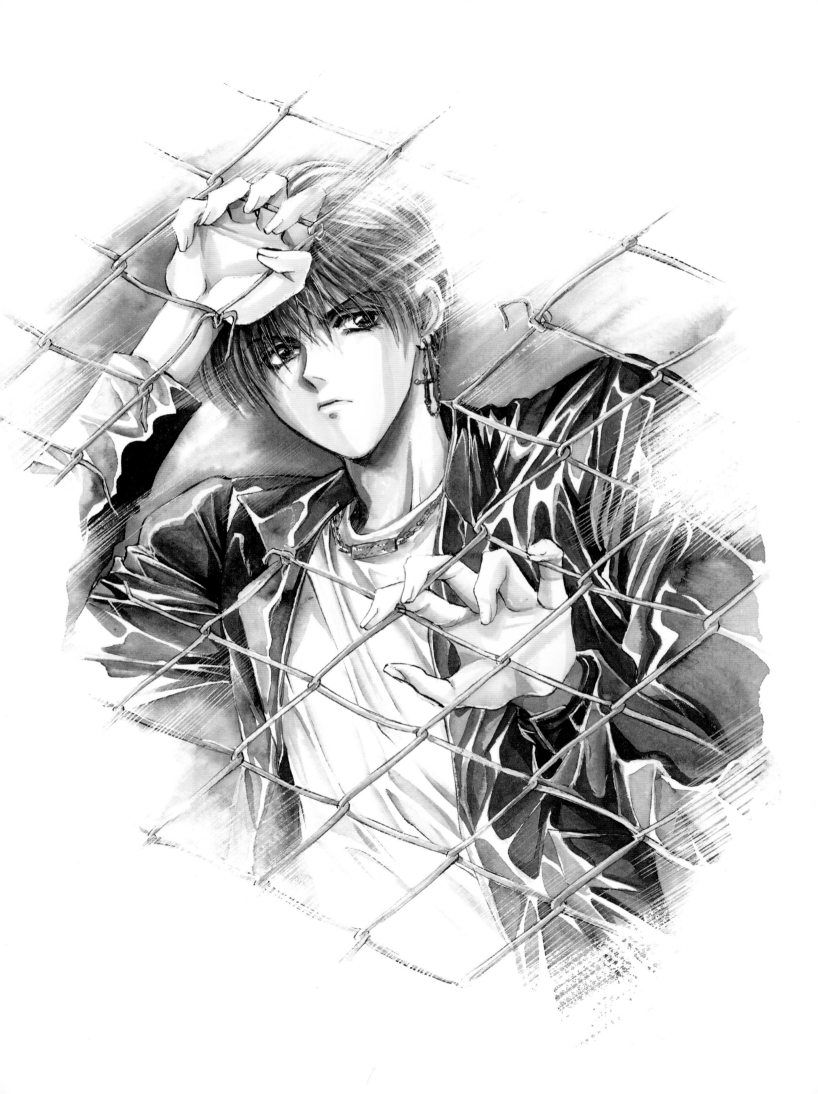

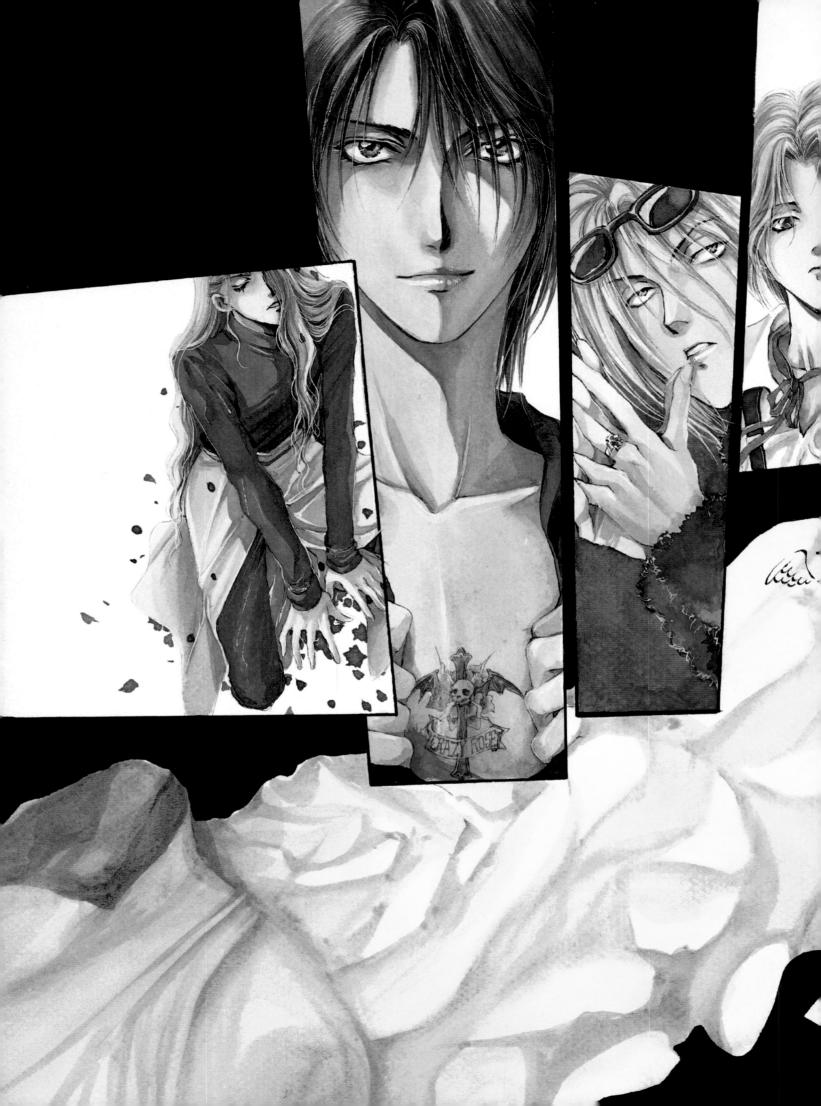

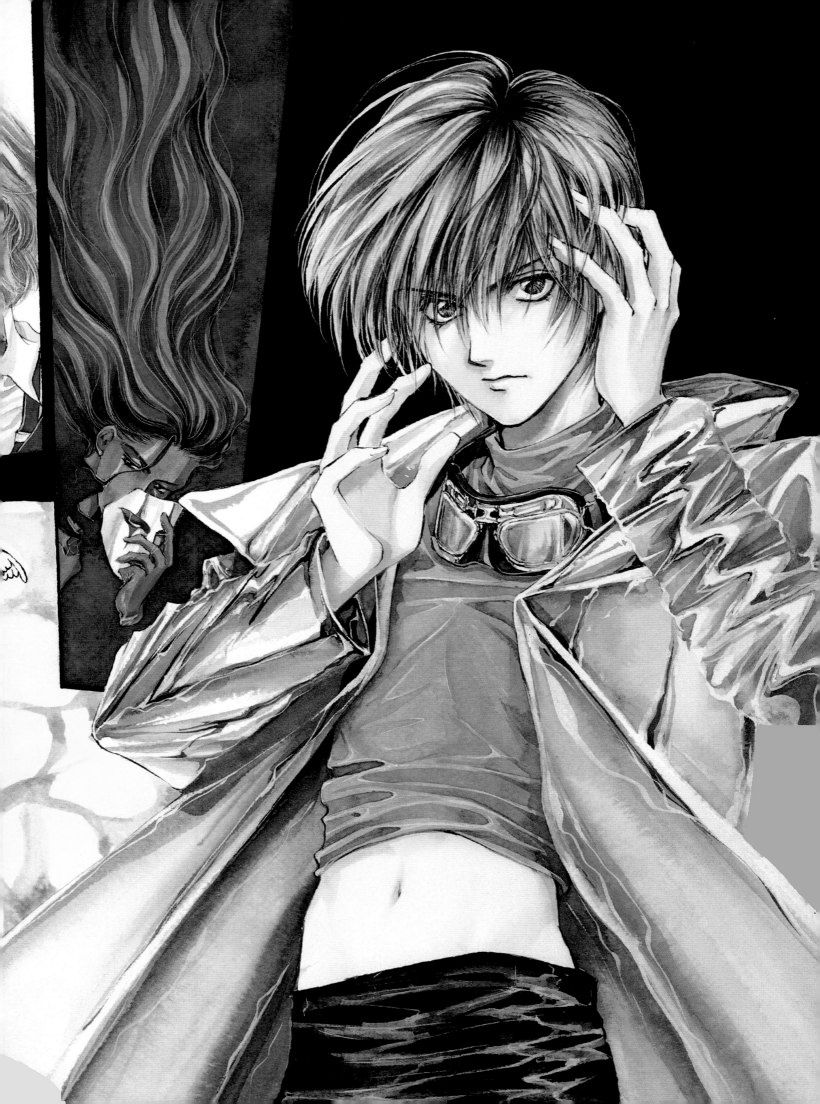

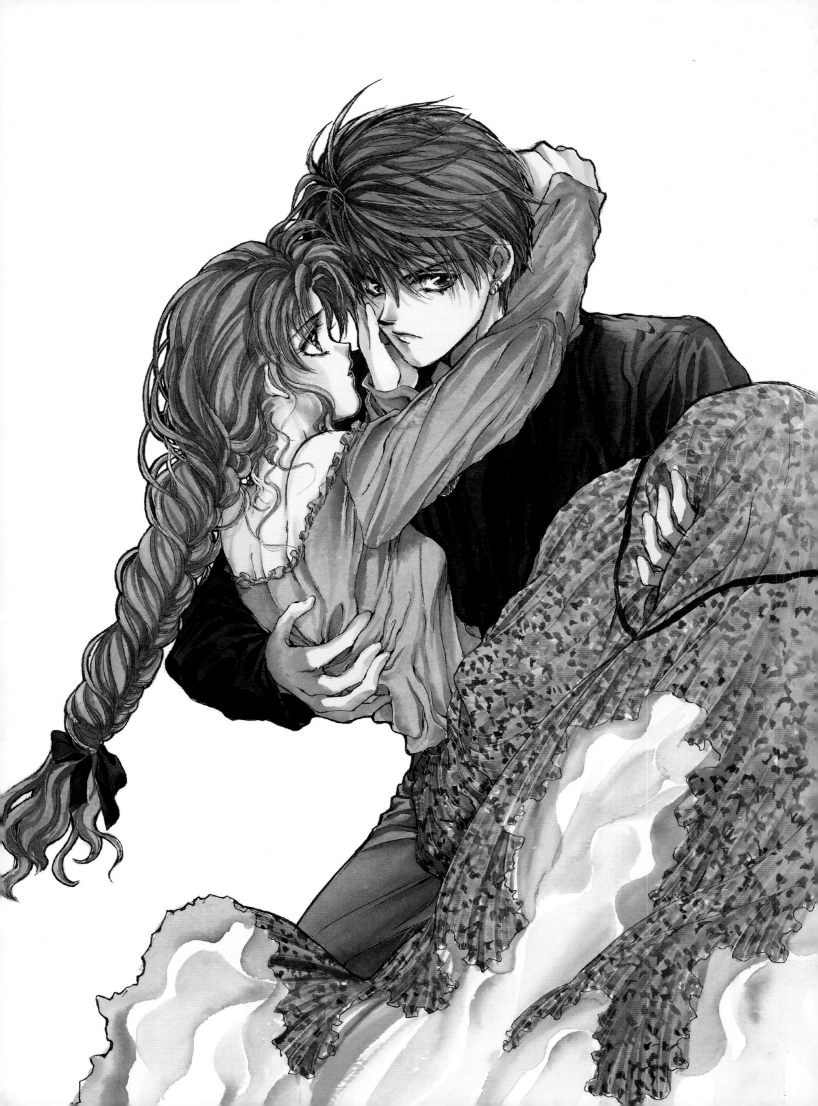

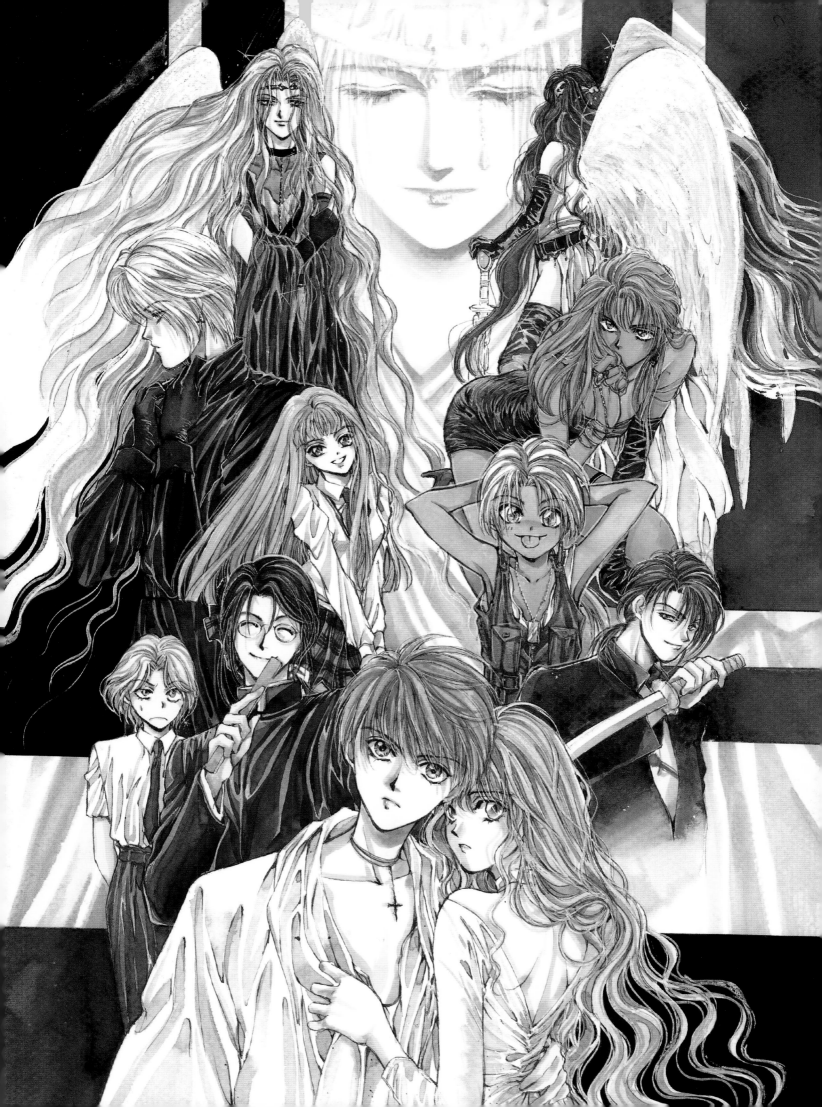

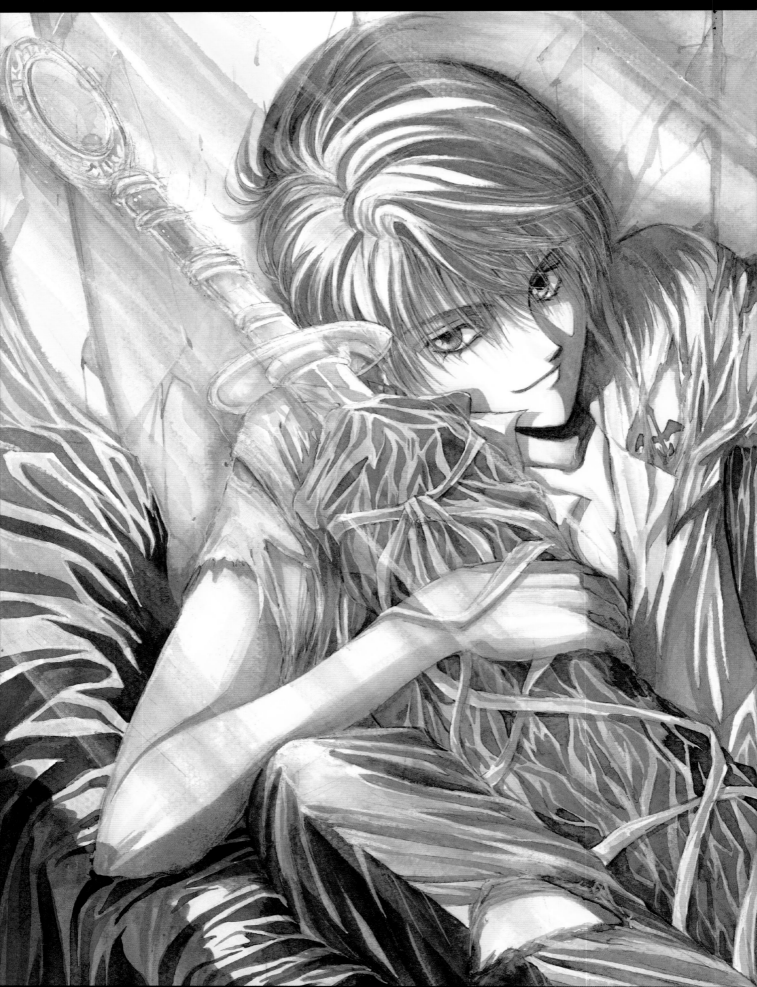

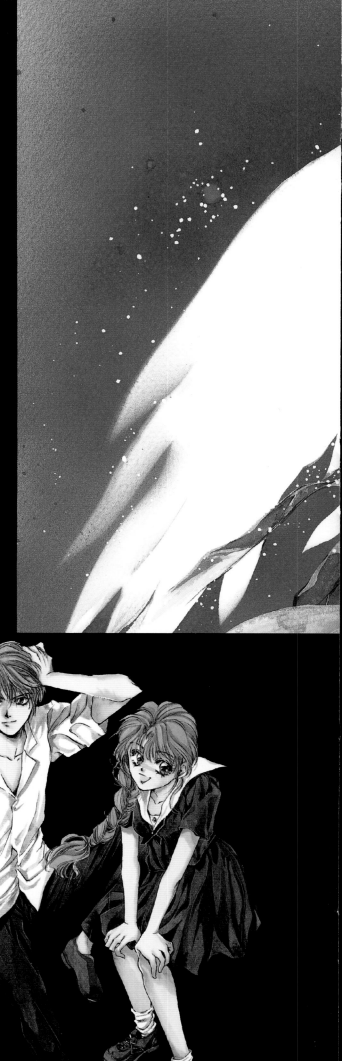

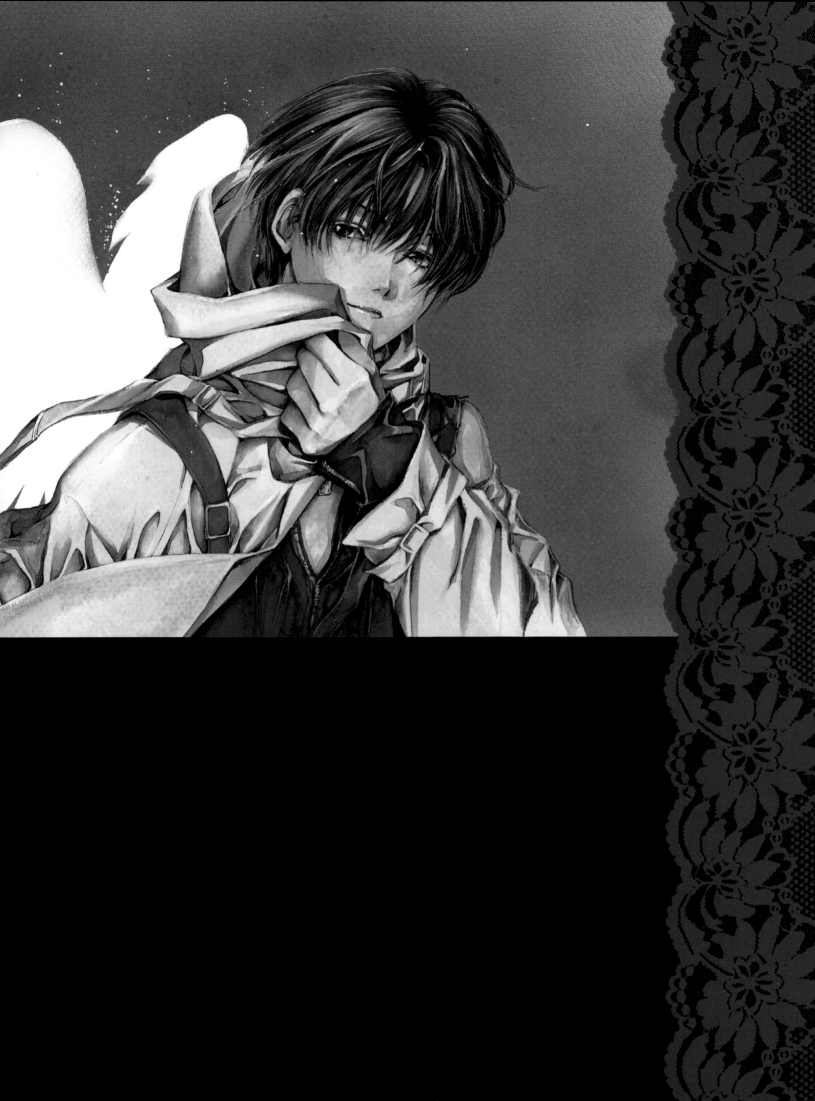

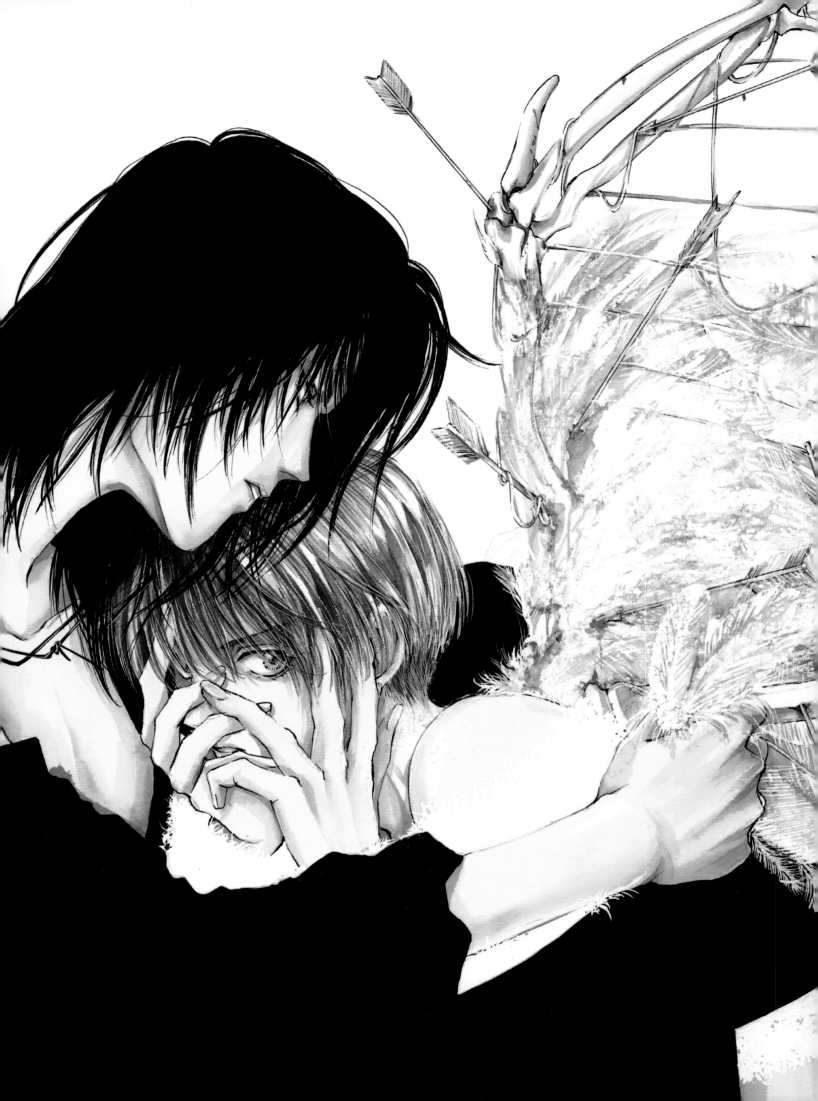

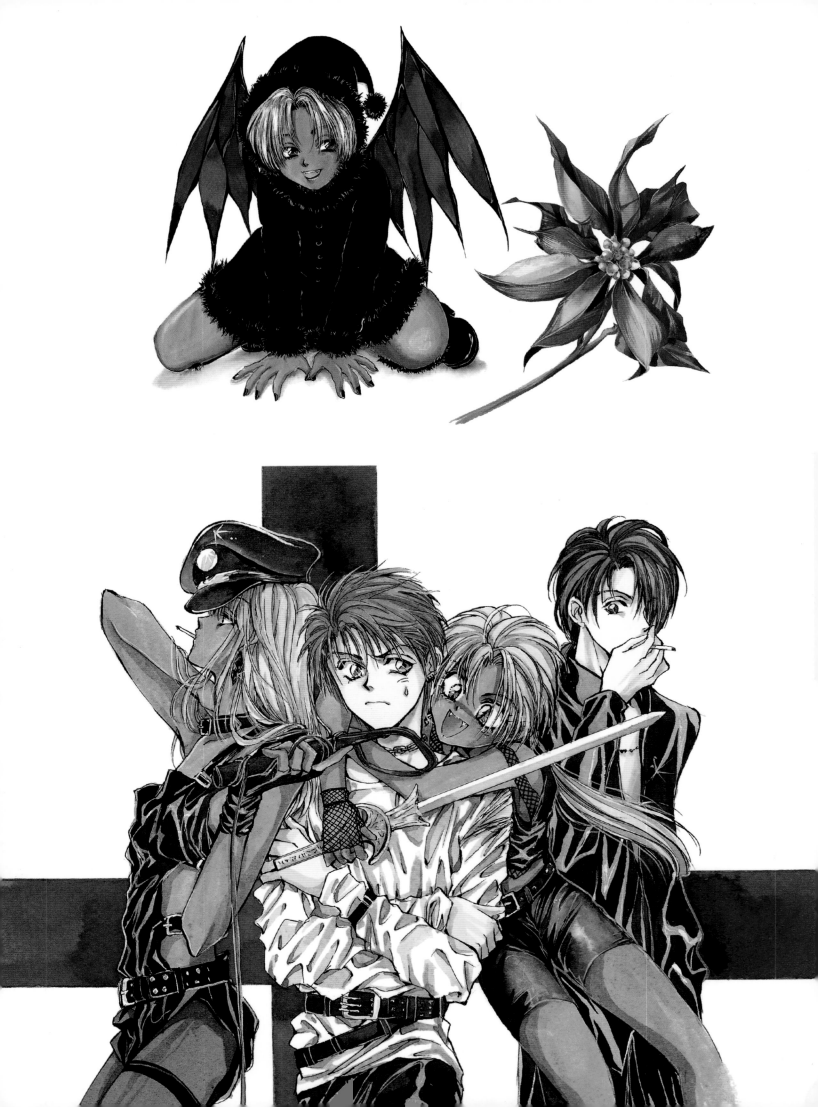

Title Pages Collection

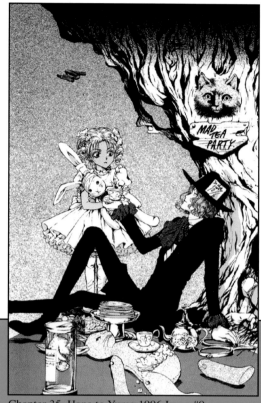

Chapter 35 Hana to Yume 1996 Issue #9

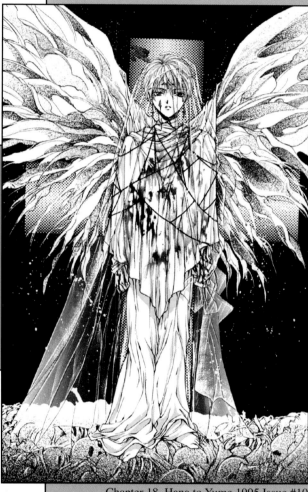

Chapter 18 Hana to Yume 1995 Issue #10

Chapter 7 Hana to Yume 1994 Issue #22

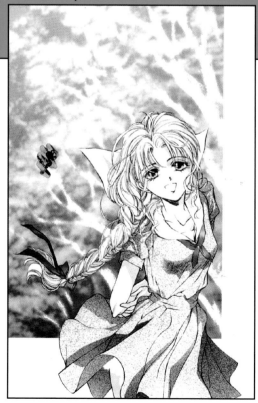

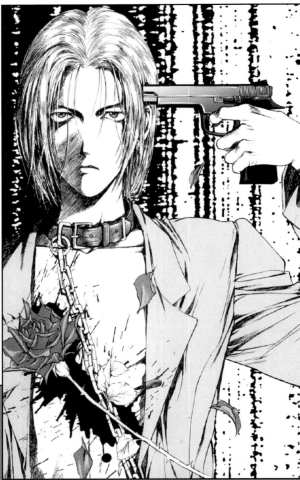

Chapter 26 Hana to Yume 1995 Issue #20

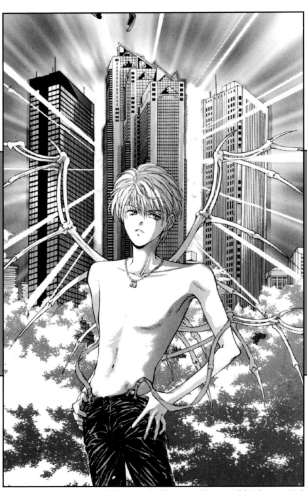
Chapter 2 Hana to Yume 1994 Issue #16

Chapter 30 Hana to Yume 1996 Issue #1

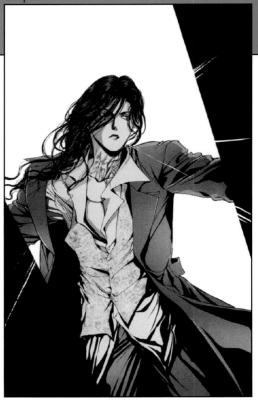

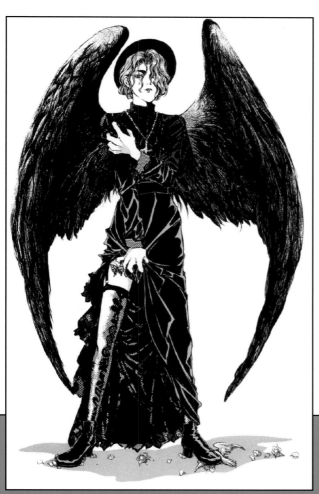

Chapter 41 Hana to Yume 1996 Issue #17

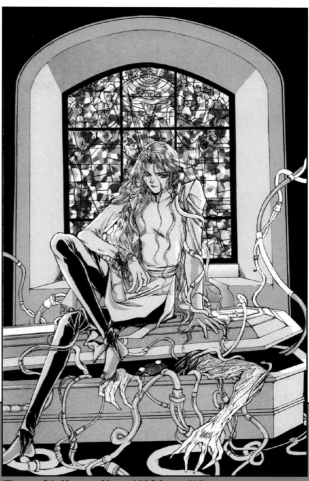

Chapter 24 Hana to Yume 1995 Issue #18

Chapter 47 Hana to Yume 1996 Issue #24

Chapter 48 Hana to Yume 1997 Issue #1

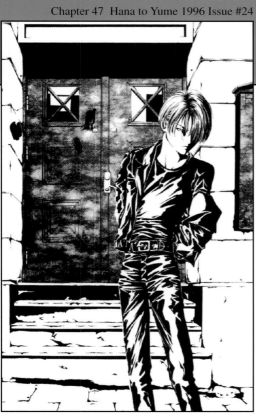

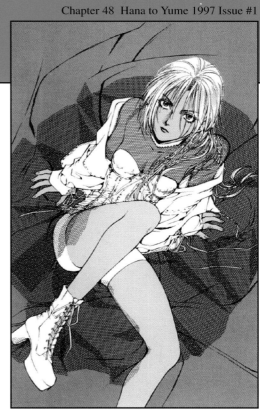

Tokyo

Right before Tokyo was destroyed, time stopped. Full of human ambition and negativity, Tokyo has become an evil city with infinite power. It may even cause the destruction of the entire planet.

Assiah

The world where the beings with no Astral power live, like humans—also called Earth. A weak plane of existence that lies between Heaven and Gehenna.

Lineage of

Seventh layer	**Araboth**
Sixth layer	**Zebul**
Fifth layer	**Mathey**
Fourth layer	**Machonon**
Third layer	**Shehaqim**
Second layer	**Raqia**
First layer	**Shamayim**

Sakuya Kira

(Nanatsusaya Spirit Sword)

The current form of the legendary sword that shifts from human body to body in order to keep protecting Alexiel. He is also the one who released her from her unending loop of hellish reincarnations. He used to be a holy sword, but killing so many has caused him to become an evil sword that seeks blood.

Setsuna Mudo

(Alexiel)

A young man who is the reincarnation of the Angel Alexiel. His organic Angel powers awaken with Sara's death. His enormous astral power causes the destruction of Assiah. In order to save Earth and Sara's soul, he heads for Heaven and the Tower of God.

Organic Angel

Alexiel

She rebelled against God and the way Heaven was run, but was captured and had her mind and body ripped apart. As punishment, she must now be reincarnated and violently killed in an endless loop of tragic lives.

Ruri Saiki

She was Sara's friend, but was possessed by the "Angel Sanctuary" computer program and killed. Because her data and spiritual power were taken by Rosiel, she is an unfortunate girl who is under his control even after death.

Sara Mudo

A young girl who loves her brother Setsuna, and dies saving him. Her soul is sent to Hell for the sin of incest, but Zaphikel brings her to Heaven.

Cherubim

Great Cherubim Jibril

Guardian of Water. Loved by all as a kind and helpful person, she suddenly lost herself and has been locked up in the water garden. She awakened thanks to Metatron, but her soul is…?

Officer Candidate Raziel

Has the special empathic ability of understanding and helping others using only his mind. Because of this ability, he was sent to the "lab" to be experimented on, but was saved by Zaphikel.

Fallen Angel

Teiaiel

A fallen Angel who can hear the voices of the dead. She lived in the slums before being captured. After hearing Katan's voice, she tries to go with him to the kingdom of light, but is killed.

Angel Sanctuary Plan

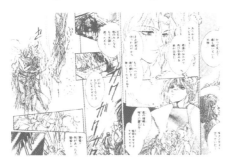

In order to free Rosiel from the seal that Alexiel bound him with, Katan used dark magic to create the "Angel Sanctuary" plan.

His plan called for the computer software "Angel Sanctuary." Using this software, electrical energy and human spiritual power were absorbed by Rosiel. This power was then used to undo the seal. This caused Tokyo to suffer a temporary blackout.

Where is God…?

God is sleeping. A very deep and long sleep… They say that when the stars align to create the Grand Cross, God's power wanes and the devil's power increases. God is asleep, saving his power for that moment.

However, contrary to what God expected, the Angels in charge of protecting Heaven and Earth are fighting amongst themselves for control.

And the holy hermit, whom God sealed away, is showing signs of awakening…

Light Chart

Inorganic Angel
Rosiel

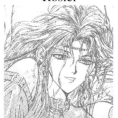

Beloved by God and the only Angel allowed in the Tower of God. He was sealed away by Alexiel during the war between Heaven and Earth, but was freed by Katan.

Adam Kadamon
Holy Hermit
Seraphita

God's greatest creation, whose six wings contain the power of all the spirits of nature, and who can even use the ancient time magic. Currently locked up in the Tower of God.

(First Level) Atziluth

Etenamenki
Tower of God

Atziluth is the holy world where God lives. Only Inorganic Angel Rosiel is allowed to live in the tower of God there. Even though Alexiel has the same Angelic rank as Rosiel, she is forbidden from even coming close to the tower. There are also rumors that the legendary holy hermit Seraphita is locked away somewhere in the tower.

Angel Hierarchy

God
▼
Holy Hermit [Adam Kadamon]
▼
Highest Angels Organic Angel
 Inorganic Angel
▼
First Class Seraphim
 Cherubim
 Thrones
▼
Second Class Dominions
 Virtues
 Powers
▼
Third Class Principalities
 Arch Angels
 Angels
▼
Working Class Grigor

• ST Candidate System
Young Angels are all sent to centers where they are taught to be proper Angels. The talented ones receive further education to become members of the Arch Angel organization.

Seraphim

Prime Minister Sevothtarte

He controls Heaven using his position as Metatron's caretaker. He is the one responsible for Alexiel's endless reincarnation loop, and for Jibril's imprisonment.

Great Seraphim Metatron

In order to be loved by all, he was created in the image of a child, but inside he's a high-ranking Angel who holds enormous power and influence. His twin brother Sandalphon died at birth.

(Second Level) Briah

Angel High Council

While God sleeps, the Angel High Council is responsible for enforcing the laws and running Heaven. Thanks to their work, Heaven is currently at peace.
Though in reality, Prime Minister Sevothtarte controls the council through fear, and a violent rival guerilla faction has emerged.

Thrones
Great Thrones Zaphikel

A blind Angel whose eyes were taken by Seraphita. On the surface, he seems to be a calm and kind person, but actually he is hiding Sara's soul and leading a rebel group against Sevothtarte.

Cherubim
Katan, Think Tank 3

He originally was a Grigor who had no body of his own, but was given a body by Rosiel, and has now earned his way up to Cherubim. He's devoted to Rosiel and will do anything for him.

Acting Great Cherubim Dobiel

Given the title of Great Cherubim by Sevothtarte to replace Jibril, Dobiel fails in the assassination of Rosiel. After that, he's given Rosiel's blood and becomes his loyal pawn.

(Third Level) Yetzirah

World of Schemes

Almost all the Angels live in Yetzirah. Here are Angel homes, education facilities and even prisons and slums.

Arch Angel
Arch Angel Candidate Kirie

Even though she's a woman, Kirie was able to steadily rise up the Angelic ranks. However, Rosiel convinces her to kill Sara, and so Kirie ends up being the one who sends Setsuna over the edge.

Powers
Powers Lieutenant Kamael

He calmly tries to guide the bratty and violent Michael. He tries to pass himself off as Michael on a few occasions, but is quickly discovered because he barely talks.

Great Powers Michael

Guardian of Fire. He has burning red hair and a very short temper. He loses it if you mention his height or his brother. After fighting Alexiel on Assiah, he's looking to settle things for good.

Virtues
Virtues Lieutenant Barbiel

The smart woman who holds the position of Raphael's second in command. Perhaps because of who her superior is, she sometimes says things that are a bit crass. She also acts as the head nurse at

Great Virtues Raphael

Guardian of Wind. He's a healer and the only one who is allowed to use the forbidden technique of resurrection. Normally he acts like a playboy who only cares about women, but…

Lineage of Darkness

Noyz

Also called Noise. She's a kind girl who cares about her brother, but she goes crazy when Mad Hatter places a curse on her. Under the Hatter's control, she tries to kill the Savior, but is saved herself by Setsuna.

Boyz

Also called Voice. He's in love with Kurai and sees Setsuna as a hated rival for her love. Because of that, he accidentally kills Setsuna's body, but is later a supporter when he witnesses the Organic Angel's miracle.

Gehenna Royalty

Arachne

Fourteenth Princess Kurai

Her mind is female but her body is male, what you'd call a transvestite. She's also of royal Gehenna blood, but is always in the shadows compared to Kurai, and resents that.

The Evils' only remaining Dragon Master. She looks up to Alexiel and is in love with Setsuna. She has a young, innocent heart and is taken advantage of by Mad Hatter…

Nature Spirits/Shinryu

The Holy Dragon Sisters rule over all nature spirits. Jade, Amber, and Agate are usually sealed within the earrings that Kurai owns. Only those chosen as the Dragon Master can call upon the Shinryu and see their true form. To everyone else, they appear as giant dragons.

Also, the blind dragon Jade can see into the future.

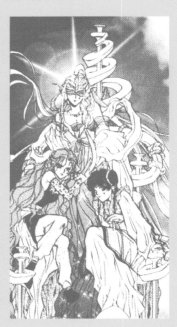

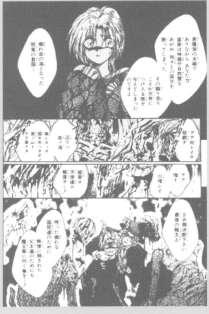

Evil Spells

The demons of Sheol know many dark traps.

They are especially adept at manipulating the human mind. With a kiss, they can place a demon within you and control your mind. And with black feathers they can affect human emotions and bring about paranoia.

Also, their bodies can revive as long as a single piece of flesh or bone remains.

Gehenna and Assiah

Gehenna and Assiah are on different sides of the same coin, so whatever changes occur in one world affect the other.

Modern human problems like pollution and destruction of nature cause even greater problems for Gehenna, where acid rain falls daily and the air and land make the Evils sick. These problems cause Gehenna to truly become Hell.

Seven Satans

Asmodeus
"Lust"
Prince of Judgment
Former Cherubim

Astaroth
"Sloth"
Marquis of Fear
Former member
of Thrones

Leviathan
"Envy"
Sea Dragon King
Former Seraphim

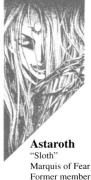

Barbelo
"Wrath"
Queen of
Darkness

Beelzebub
"Gluttony"
Lord of Flies
Former Seraphim

Mammon
"Avarice"
Golden Count

Belial

Controlled by desires of the flesh, this demon condemns many Angels to sin. A former member of Virtues who even caused the destruction of Sodom and Gomorra. Plans to make Kurai the bride of the Demon Lord.

Chart

Gehenna

World of demons and evil. The fallen Angel Lucifer, the demon lord, lives in Sheol, the lowest level of Hell where Evils cannot go.

Hades

Souls come to Hades in order to increase their spiritual level and decrease their evil. Based on how well they do, it's decided whether the soul goes through Heaven's gate or Hell's gate, which leads to Gehenna. The Hell's Gate is located inside the holy tree Yggdrasil.

Hades

The world controlled by Enra-ô. The world of the dead, where the spirits of those who die are collected. It's easy to enter but impossible to escape.

Kingdom of Gehenna

The Kingdom of Gehenna is where the Evils rule.

Evils, who are closer to humans than they are to demons, dislike the demons of Sheol, and are trying to create a world for themselves. They worship the holy Shinryu dragons and nature spirits, and live in peace.

But the Kingdom of Gehenna was suddenly destroyed one day by an attack from the Angel army.

Enra-ô's plan

It is predicted that the destruction of Assiah will cause great problems for Hades. If all the souls of earth are suddenly sent to Hades, then Hades will also be destroyed. Enra-ô must put all his faith in the Savior.

(Second level)
Stomach

(Third level)
Silence

(Fourth level)
Gate of Death

(Fifth level)
Gate of Death's Shadow

(Sixth level)
Destruction

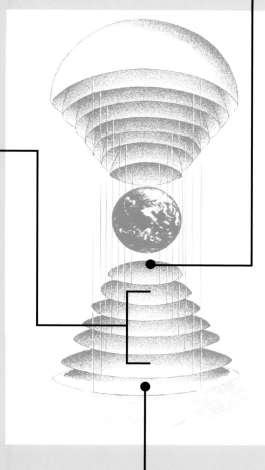

Angel of the Dead

Doll

Uriel placed a lost Angel soul into the body of a wind-up doll. She's loyal and devoted to Uriel. It seems that she was Kirie in her previous life.

Uriel

Guardian of Earth. The final judge who sends unrepentant sinners to the fires of Gehenna. He placed a curse on Alexiel using his voice, and the guilt over his actions made him rip out his own vocal cords.

Enra-ô

The leader of Hades who keeps the souls in order. He's composed of numerous high spirits. He tricked and manipulated Kato and brought danger to Setsuna.

Nidheg

A former Angel put to death for a crime he did not commit. He was a ghoul in Hades until Uriel rescued him. He still loves the woman who framed him and caused him to be executed.

Demon Lord

Lucifer

A fallen Angel who turned his back on God and was banished from Heaven. Lucifer rules Gehenna with a power that even God fears. He's trying to bring Kurai and Setsuna on his side to defeat the Angel Army, but…

(Seventh Level) Sheol

The Pit of Hell

The farther you get from Gehenna, the harder it is to live.

Meaning that the lower you go, the stronger the demons that live there get.

However, those who rule Sheol are Angels who have been banished from Heaven.

Lailah

The person loved by the Angel who becomes Nidheg. She was attacked by fellow Angels, but ended up killing her attackers. In order to hide her crime, she framed the people who came to her aid.

Yue Kato

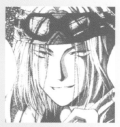

He tried to kill Setsuna and absorb his power, but failed. He later works together with Setsuna to overcome his past and fight his destiny.

The Abyss of Angel Sanctuary

Here are explanations of some of the terms used in Angel Sanctuary.

• Astral Power (Astral Light)
The spiritual power of non-human creatures. Emitted from the wings. Many kinds of magic can be performed with this power. Without this power, you are not able to see the true form of the world.
Humans can see Astral power as an aura, but very few are aware of this.

• Enochian
The alphabet used by Angels. The blind Zaphikel can read these letters by touching them.

• Six Wings
The wings of the holy hermit, Seraphita. It's said that the six wings contain all the elemental powers of the world. And the highest-ranking Angels are said to each be born with three of these wings.

• Grigor (Spirit Angels)
The lowest rank of Angels. These are working-class Angels who used to work among humans on Assiah, but because they had children with humans, God became angry and turned them into Angels who had no physical bodies. The children born among humans

and Grigor are said to have become demons that caused many evil deeds. Grigor exist in the air, and are able to take solid form only by the order of an Angel. To ensure that they will never disobey a high-class Angel, the Grigor's mental capacity is limited when they are created. And when they complete their mission, they die.

• Uriel's Mask (Persona)
It rids his mind of his conscience so that he doesn't feel guilt. And it also allows him to control ghouls.

Ragnarok

The world was supposed to be destroyed in July 1999, but the Holy Hermit Seraphita stopped the "Assiah Destruction Program."

This program was supposed to activate when Setsuna's sister Sara was killed and the soul of the Organic Angel wakened. The world, unable to withstand Setsuna's incredible amount of Astral power, would be destroyed.

Grand Cross

The cross formed by the stars of the zodiac. When the Grand Cross is seen, God's power is weakened and the Devil's power increases. Because of this, it's not hard to imagine that the Devil would try to rebel against God during this time.

With the Grand Cross close at hand, God is sleeping and amassing his energy.

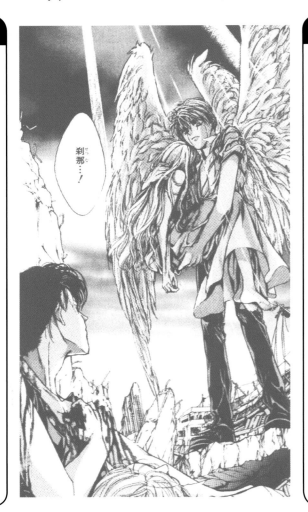

War between Heaven and Earth

War between Heaven and Earth

The War between Heaven and Earth refers to the Angel Army attacking the weakened Gehenna and destroying it. At this point, the Organic Angel turned against God and the war became more serious.

In the end, the war became a battle between the Organic and Inorganic Angels and ended when the Inorganic Angel was sealed away and the Organic Angel was captured.

Alexiel and Rosiel

Organic Angel Alexiel and Inorganic Angel Rosiel were created as a single Angel. However, God only loved Rosiel and was cold to Alexiel. It's said that this caused her to take up her sword.

Supposedly, Rosiel is unable to deal with his own contradictions and is starting to lose his mind.

• Earth Commandment Spell
The final magic used by Organic Angel Alexiel to bind Inorganic Angel Rosiel. Rosiel's soul was sealed deep into the earth of Assiah.

• Puppets
These are the dolls that Rosiel creates. By feeding people his feathers, Rosiel is able to create puppets that obey only him. Angels eventually return to their former selves, but humans who lack Astral powers become ugly freaks. Humans who become puppets are not able to rest in peace, and very few have the power to exorcize them. Organic Angel Alexiel is one of the few who can.

• Alcorns (Dark Angels)
Former high-ranking Angels who joined with Lucifer in his rebellion against God and were banished from Heaven. Belial, Astaroth, and the other Seven Satans are among them.

• Ghouls
Freaks in Hades who eat spiritual bodies. They are Angels who committed crimes and were put to death. Angels who become Ghouls lose their minds and memories, and seek out spirits to eat and fill the holes in their hearts.

• Capital of Corruption—Sodom and Gomorra
A small city on the outskirts of the Dead Sea that was victimized by Belial's trick. After having their morals taken from them by Mad Hatter, the people drown in pleasure and lose all reason. Looting, killing, raping, and all types of corruption became common as the people were overcome with sin. God, angered by this, destroyed the city with fire and sulfur.

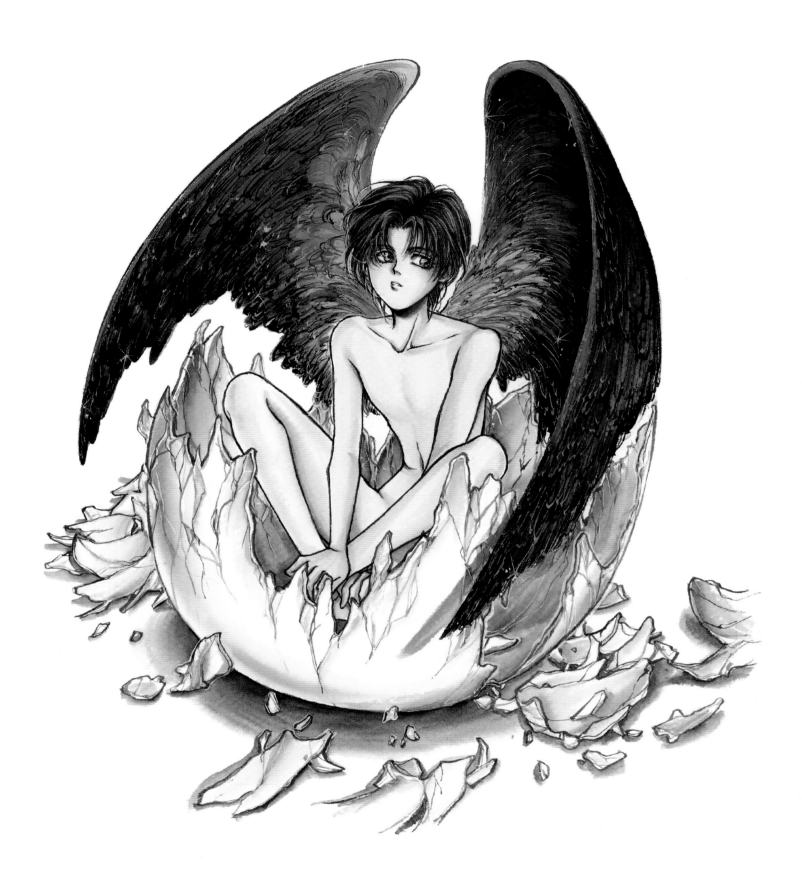

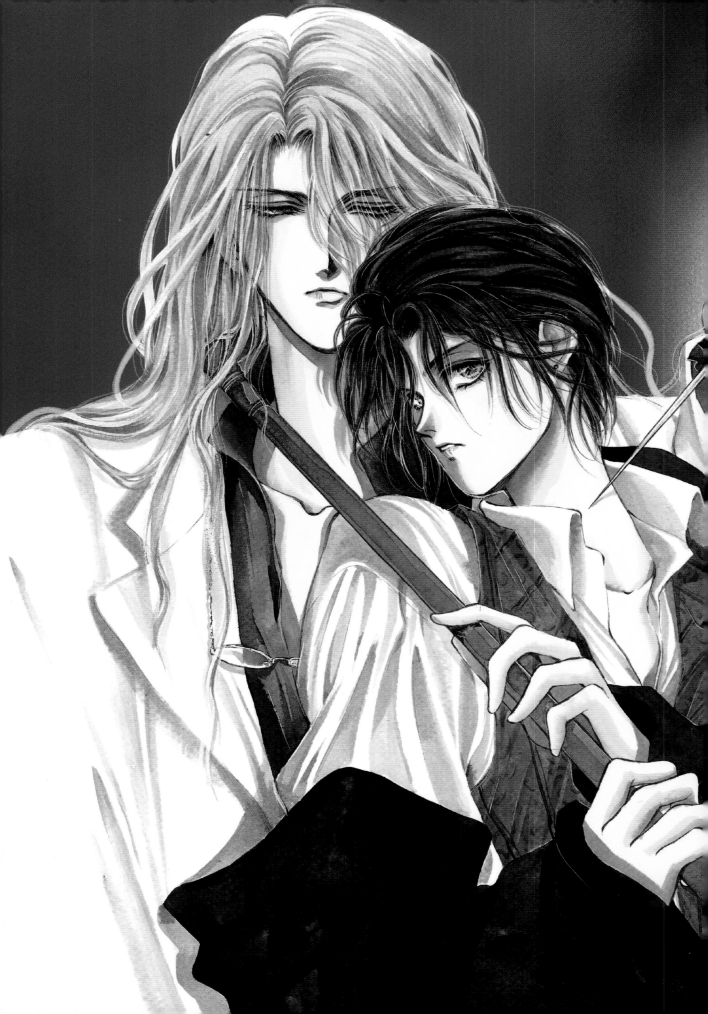

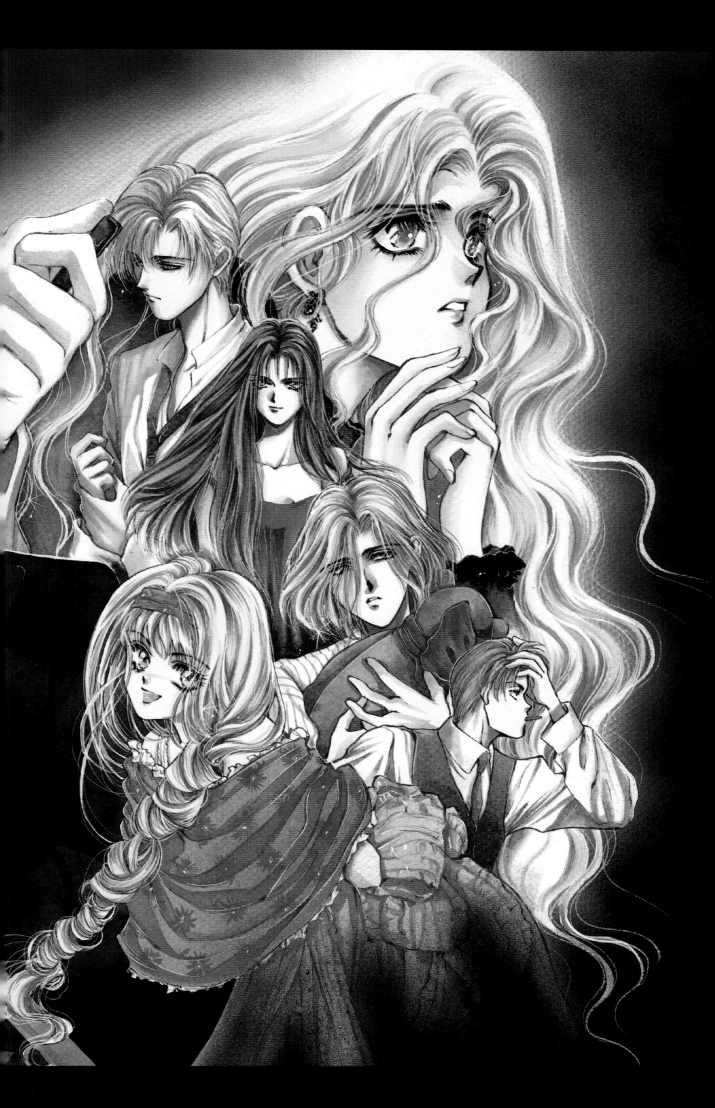

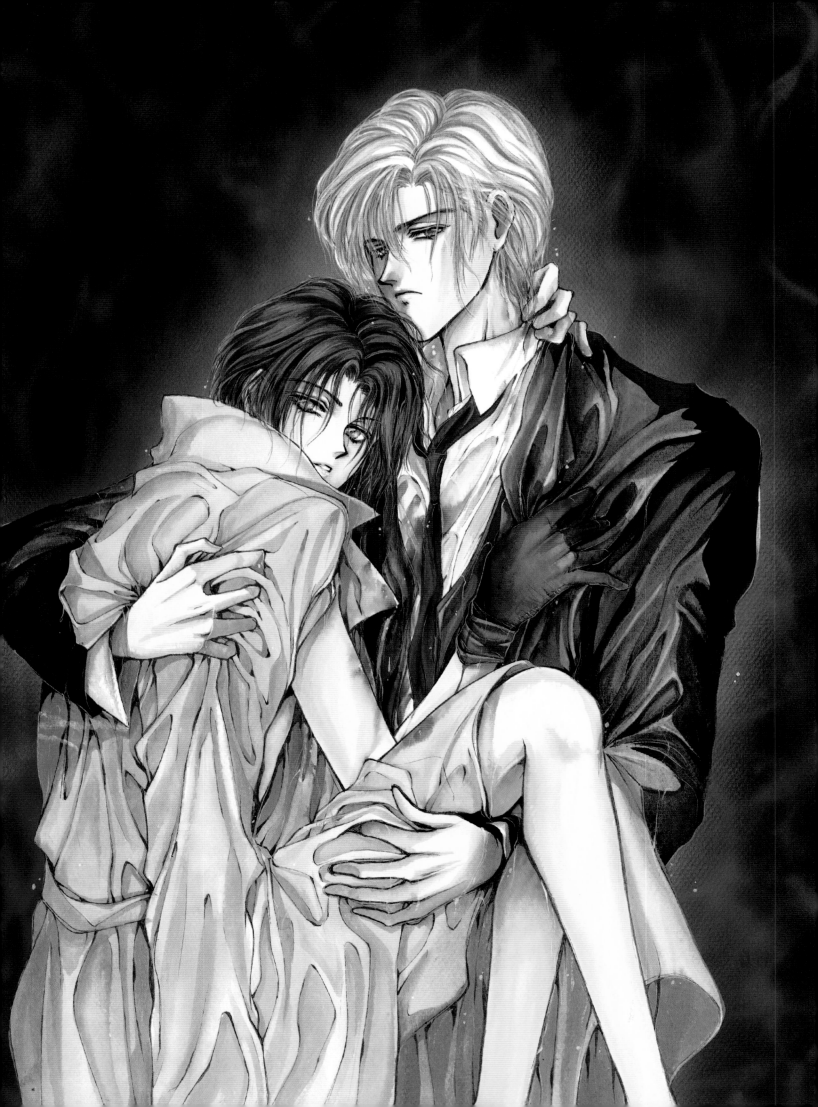

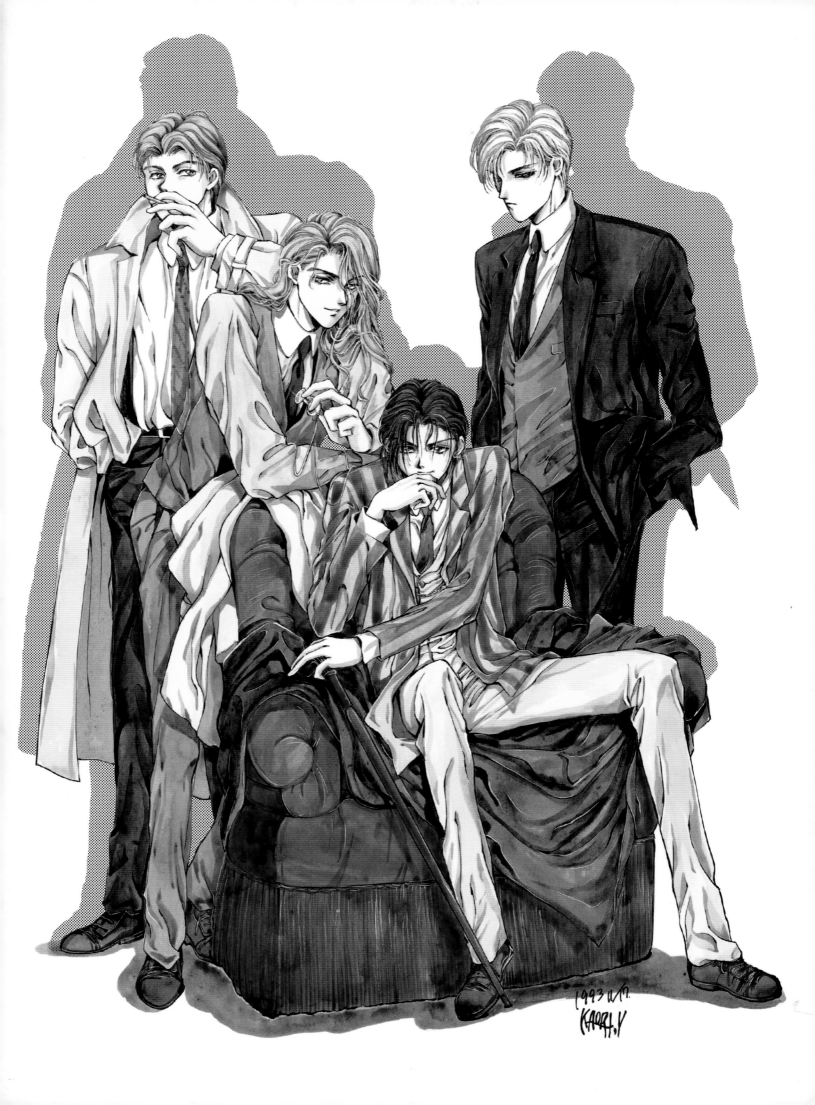

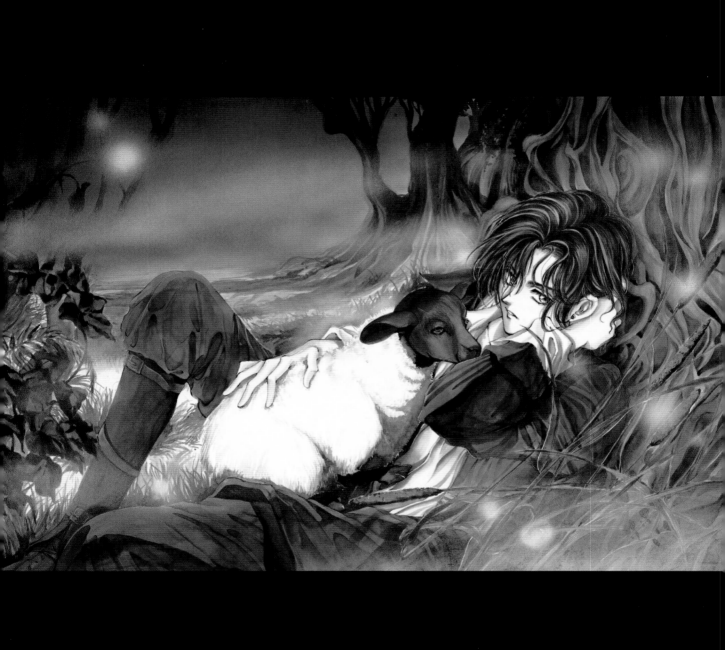

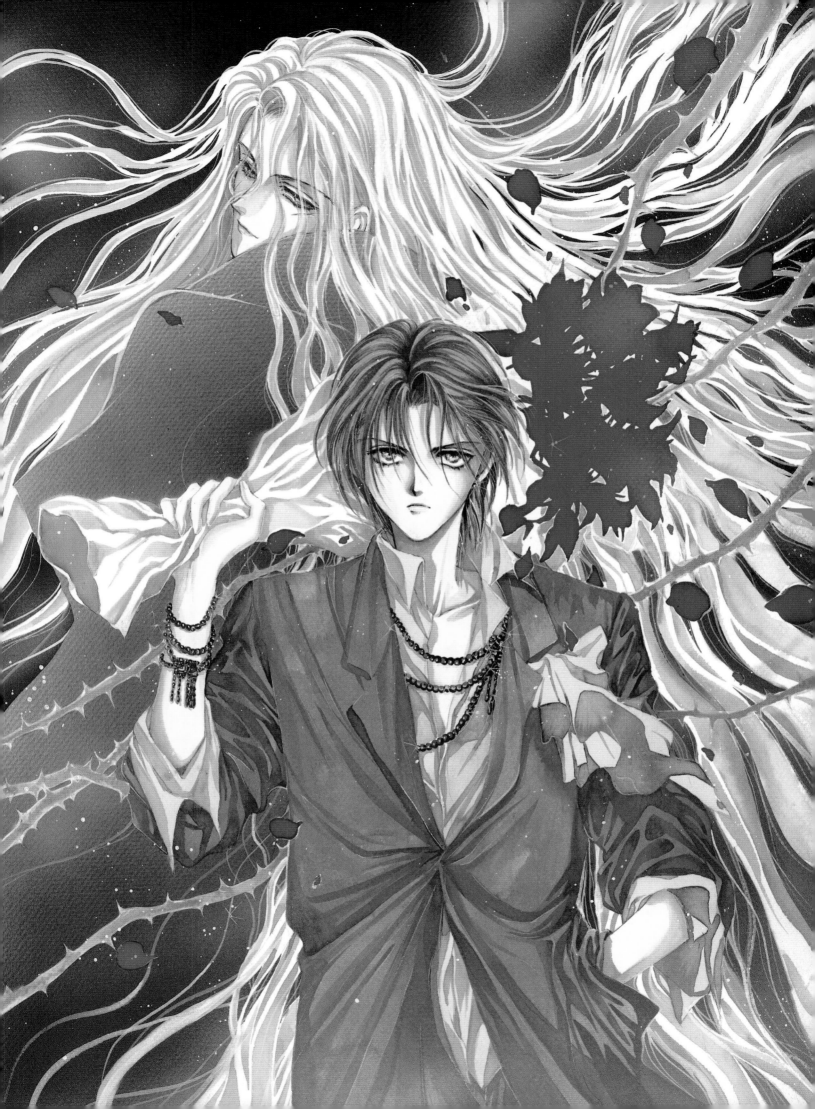

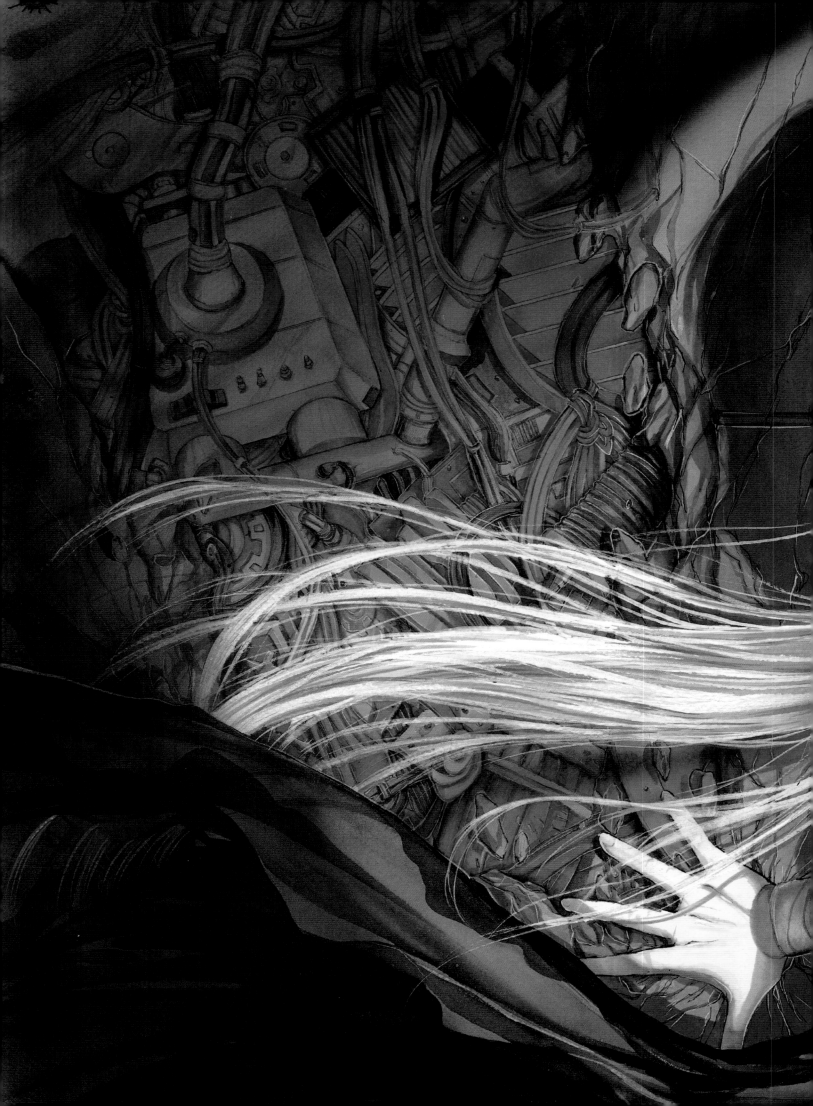

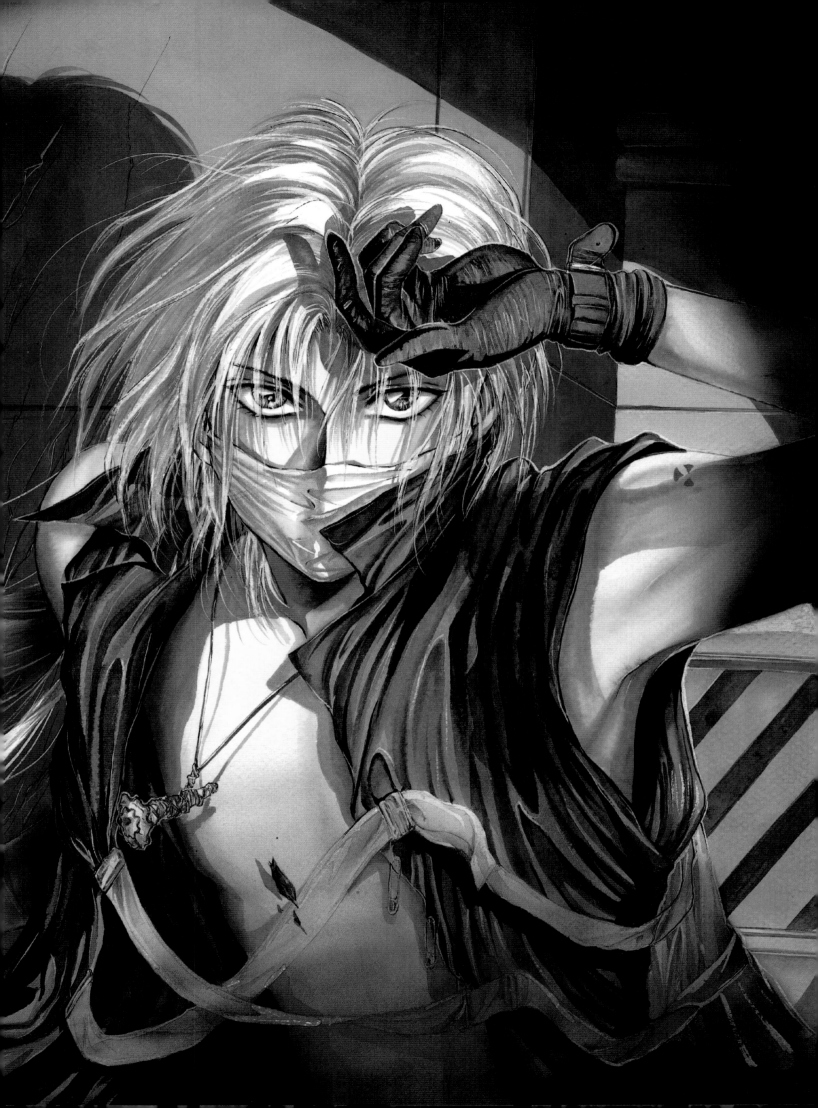

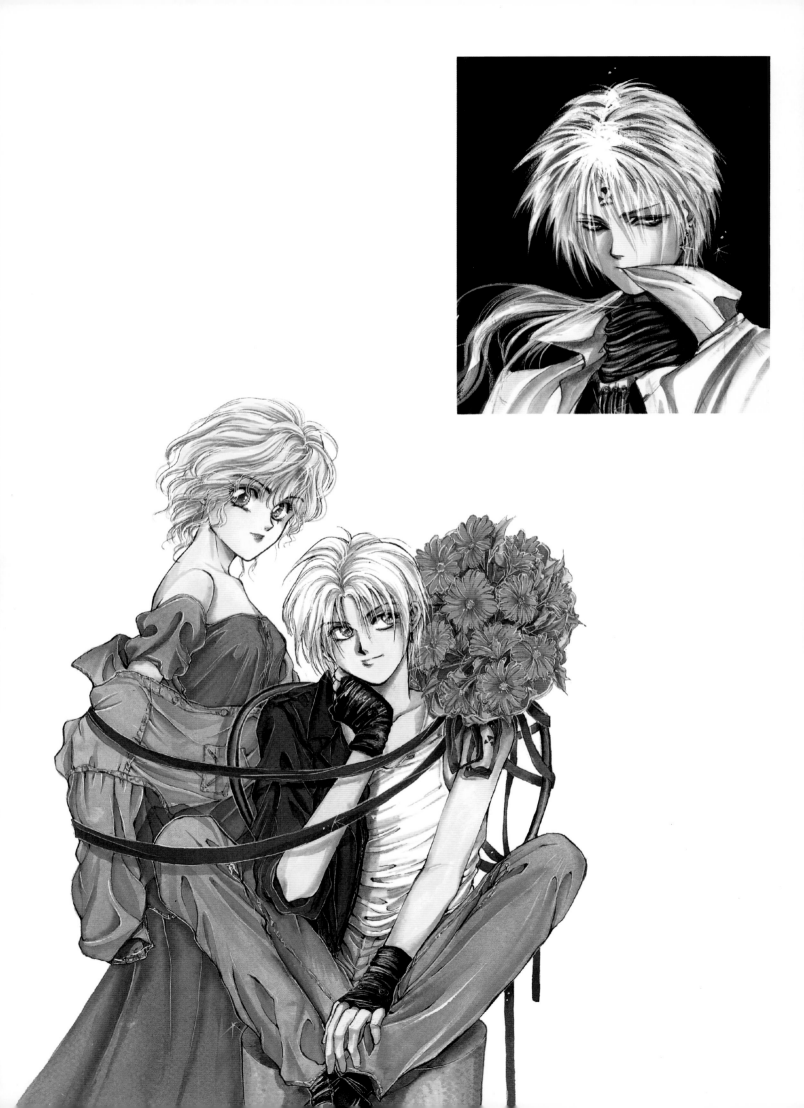

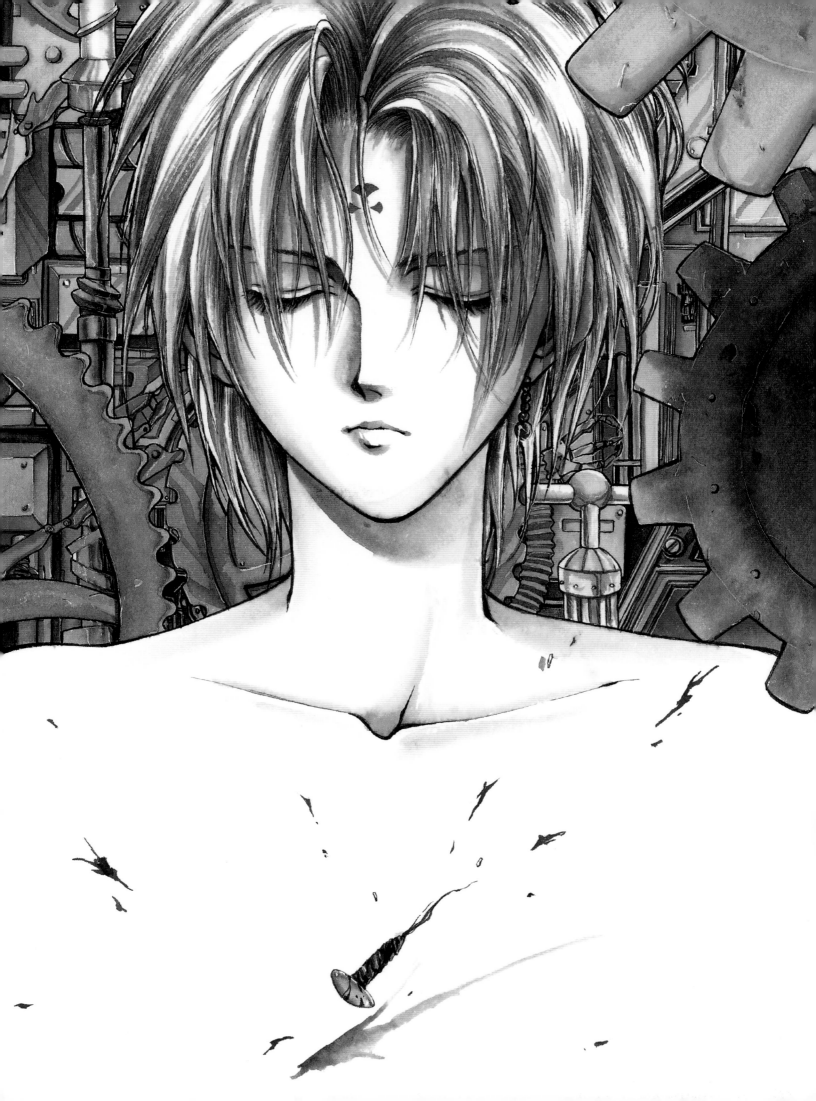

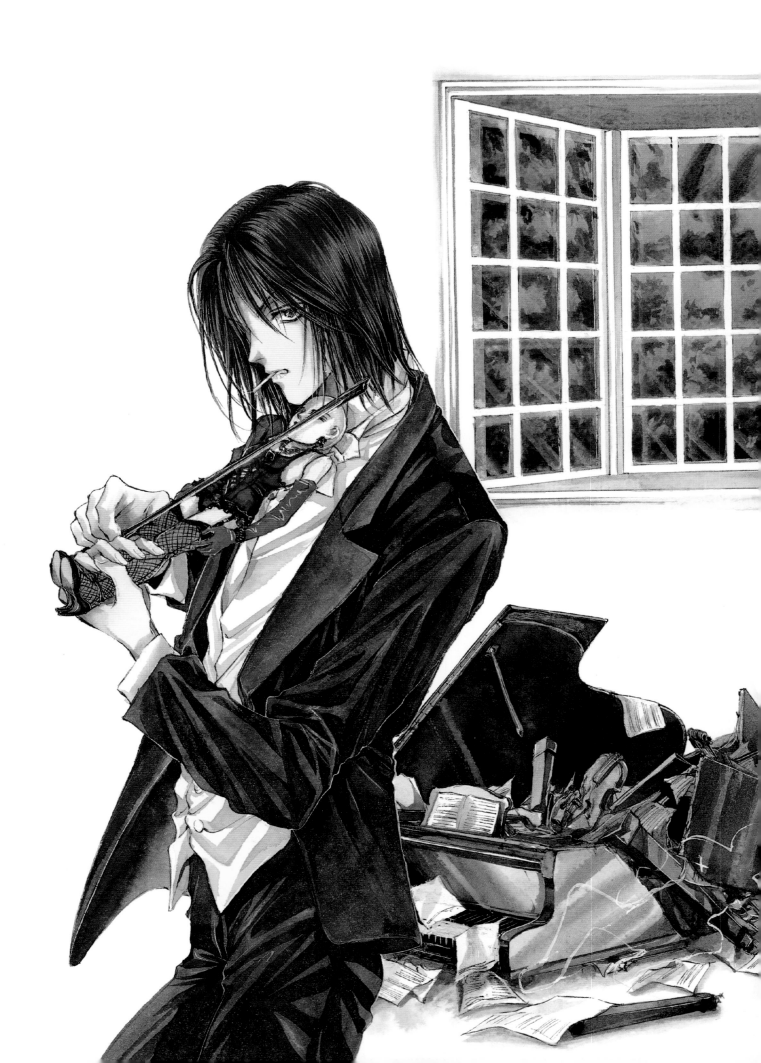

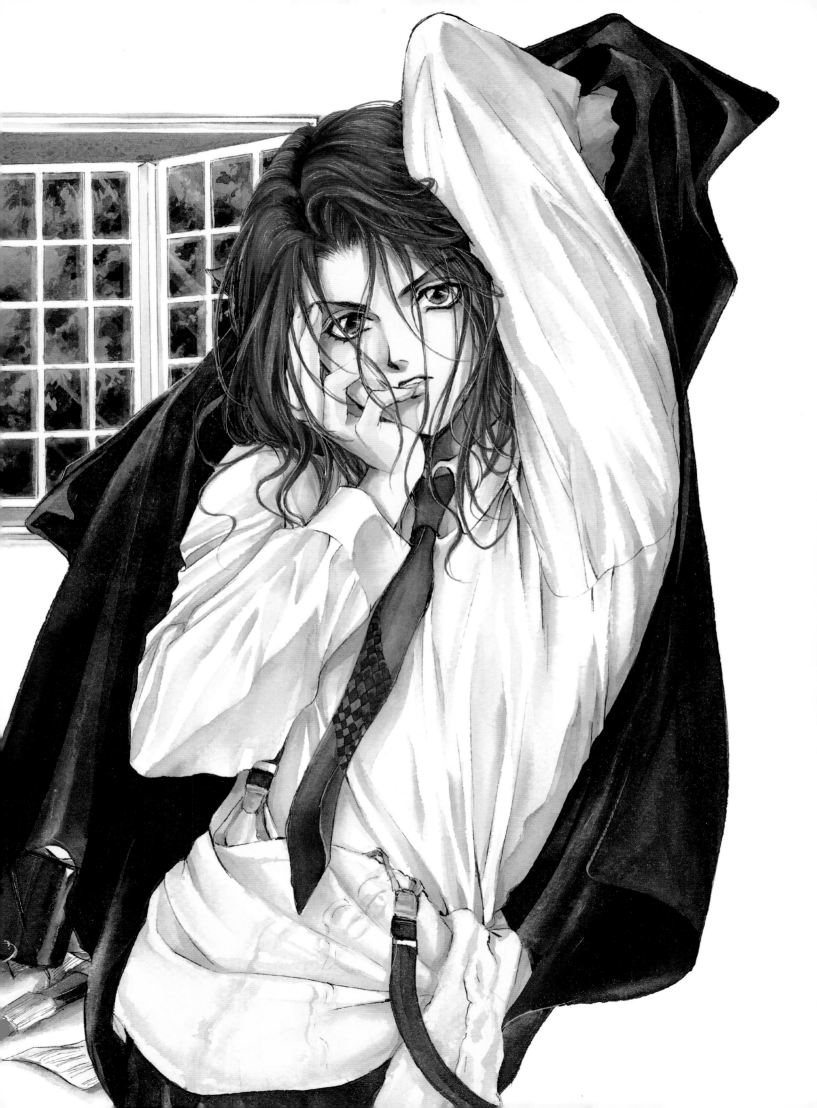

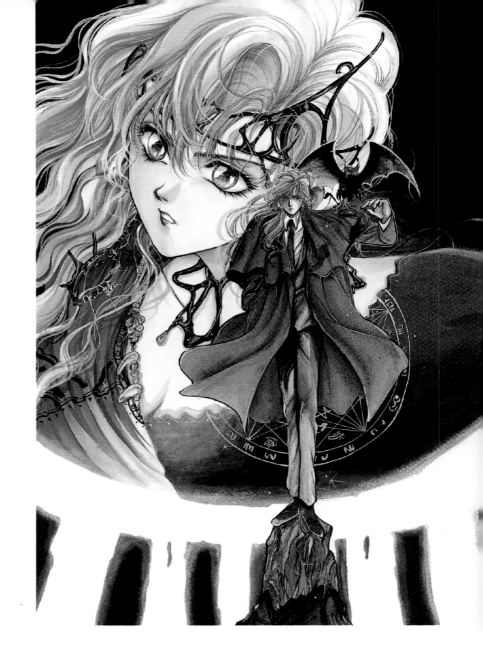

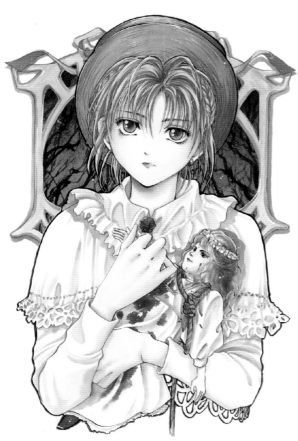

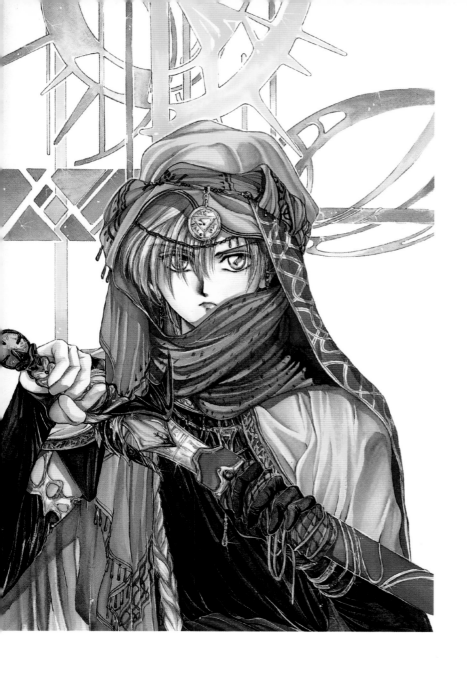
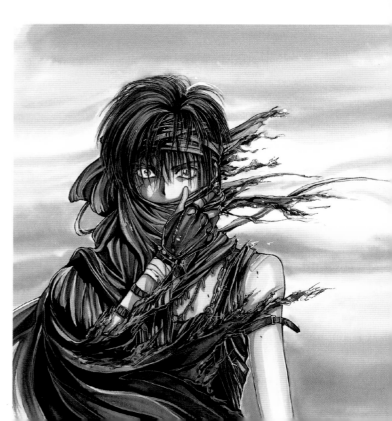

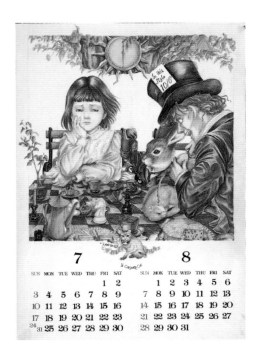

7

SUN	MON	TUE	WED	THU	FRI	SAT
					1	2
3	4	5	6	7	8	9
10	11	12	13	14	15	16
17	18	19	20	21	22	23
24 31	25	26	27	28	29	30

8

SUN	MON	TUE	WED	THU	FRI	SAT
	1	2	3	4	5	6
7	8	9	10	11	12	13
14	15	16	17	18	19	20
21	22	23	24	25	26	27
28	29	30	31			

1

SU	MON	TUE	WED	THU	FRI	SAT
					1	2
3	4	5	6	7	8	9
10	11	12	13	14	15	16
17	18	19	20	21	22	23
24 31	25	26	27	28	29	30

2

SU	MON	TUE	WED	THU	FRI	SAT
	1	2	3	4	5	6
7	8	9	10	11	12	13
14	15	16	17	18	19	20
21	22	23	24	25	26	27
28	29					

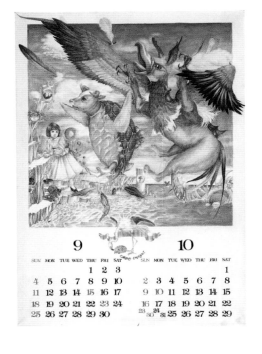

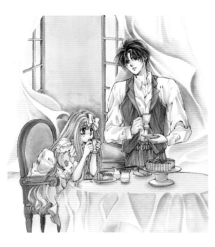

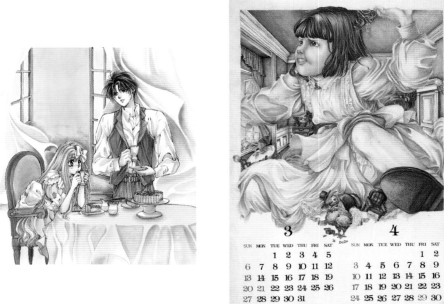

9

SUN	MON	TUE	WED	THU	FRI	SAT
			1	2	3	
4	5	6	7	8	9	10
11	12	13	14	15	16	17
18	19	20	21	22	23	24
25	26	27	28	29	30	

10

SUN	MON	TUE	WED	THU	FRI	SAT
						1
2	3	4	5	6	7	8
9	10	11	12	13	14	15
16	17	18	19	20	21	22
23 30	24 31	25	26	27	28	29

3

SUN	MON	TUE	WED	THU	FRI	SAT
		1	2	3	4	5
6	7	8	9	10	11	12
13	14	15	16	17	18	19
20	21	22	23	24	25	26
27	28	29	30	31		

4

SUN	MON	TUE	WED	THU	FRI	SAT
					1	2
3	4	5	6	7	8	9
10	11	12	13	14	15	16
17	18	19	20	21	22	23
24	25	26	27	28	29	30

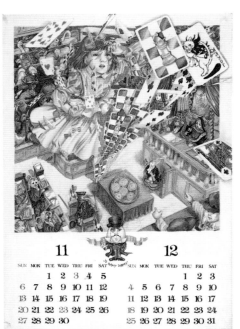

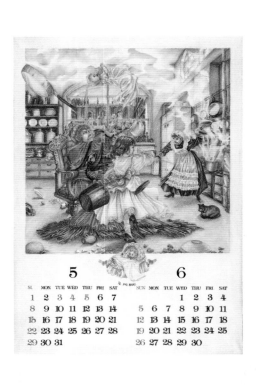

11

SUN	MON	TUE	WED	THU	FRI	SAT
		1	2	3	4	5
6	7	8	9	10	11	12
13	14	15	16	17	18	19
20	21	22	23	24	25	26
27	28	29	30			

12

SUN	MON	TUE	WED	THU	FRI	SAT
				1	2	3
4	5	6	7	8	9	10
11	12	13	14	15	16	17
18	19	20	21	22	23	24
25	26	27	28	29	30	31

5

SU	MON	TUE	WED	THU	FRI	SAT
1	2	3	4	5	6	7
8	9	10	11	12	13	14
15	16	17	18	19	20	21
22	23	24	25	26	27	28
29	30	31				

6

SUN	MON	TUE	WED	THU	FRI	SAT
			1	2	3	4
5	6	7	8	9	10	11
12	13	14	15	16	17	18
19	20	21	22	23	24	25
26	27	28	29	30		

 Kaori Yuki Interview

The March Hare's Tea Party

Welcome to Kaori Yuki's chic
and elegant tea party.

The sweet yet cruel girl from "Wonderland."

----Today I'd like to dig deep into Kaori Yuki's world.
First, I hear that a lot of motifs in your work are based on *Alice in Wonderland*. What is it about that work that attracts you so much?

At first I had only seen the Disney "Alice," and didn't like it at all. But I looked further into the original story and learned that it was actually completely different from that movie.

----Disney animated movies do alter the original stories a lot.

Alice is supposed to be much younger, like about six years old? She has short black hair and is cute in a young little girl kind of way. Also, I really like the author's name. Lewis Carroll just has such a nice ring to it. But I don't actually like the story that much, because it's hard to understand. I also don't really like the characters all the much either, but I love the atmosphere. Like Mother Goose, I like how it's cruel yet elegant.

----I understand. Like how there's no blood, but it can be scary.

Yes yes! The Queen who says "off with your head," she's so cruel. Plus many of the things Alice herself says are cruel. The cruelty of a young child. When she thinks she might have turned into one of her friends, she whines and says, "That girl is stupid and poor and lives in an ugly house, I don't want to be her!!!" I enjoyed reading that and thought "Girls can be

so cruel…" There's also a word game and a page that has words written like a rat's tail, just lots of fun things in the book, that's what attracted me, too. And the original art that Lewis Carroll drew himself is creepy and nice.

----Do you have his original art?

Yes, I have the original book version that he gave to Alice.

----(The books in the pictures below are Kaori Yuki's *Alice in Wonderland* books.)

I used this book for reference when I created my Alice Calendar. The art in it is creepy. For example, the scene where Alice's body gets bigger: it's not that her whole body gets bigger but that her neck gets really long. I thought something was strange when I saw this scene in the Disney movie. Why would a bird say "snake snake!" when seeing Alice's big body? But I understand from seeing this picture. By the way, in the scene where she shrinks, the art shows her head attached to her shoes. Oh, I also like Dodos. Lewis Carroll's real name is Dodgeson and that name changes and becomes Dodo. I like the shape of Dodos and the fact that they are extinct just adds to their luster, I think.

Adding a British taste to the story.

----You have many stories that take place in England– is there a reason for that?

Alice in Wonderland is also a British story, but you know how food appears in the story? Mother

Goose, too. Tea parties and things coming out of pies, and stuff like that. The story is scary, but has a certain elegance to it. I don't know that much about British society and culture, and that makes me worry sometimes as I write a story, but it also makes it so I'm not tied down to anything.

----So you don't need to be bound hand and foot to try to maintain historical accuracy?

I think that's what entertainment is all about. Using a British motif and adding something from a Mother Goose song to make it scarier. That just makes it much more fun.

----So bringing in an existing British idea into the Kaori Yuki world.

It's probably impossible to come up with a completely original idea. I doubt there are any creators who have been able to make it very far without being influenced by someone else. I think you have to pull in as many influences as you can and then add your own flavor to it.

Things you hate but love.

----Earlier we said that what makes *Alice in Wonderland* attractive is its unique scariness, but what are other scary things that captivate you?

I'm afraid of ghosts and don't want anything to do with them. I get so scared when I think about them existing for real that I don't want to even think about it. That's why I like the world of make-believe. The things you come up with are not reality. For example, there's a scary movie that I like…

Alice in Wonderland

It's known as a children's book, but behind the scenes it has a lot of social commentary and wordplay in it. It was written by Lewis Carroll as a gift to a young girl in his neighborhood. It's also said that he proposed to this girl.

This is Yuki-sensei's desk. Her work space is a 10 mat room! The desks and lamps are all black, giving the room a chic feel.

…called Paper House. In this story, a girl draws a picture of her house on a large piece of paper and when she sleeps on it, the house becomes real in her dream. This movie gets pretty scary. The girl's father isn't home very much, so she draws a picture of him, but the drawing is very scary looking so she erases the area around his eyes. Later on, the father comes home inside the dream and his face looks like the picture and he's saying "why did you draw me like this?!" Scary, no? Other ones I liked were Dream Child and a German animated Alice. That one was really creepy and I loved it and kind of wanted to enter that world. Many times when I'm watching cult movies, I feel like I want to enter them. Yeah, I know it's weird… In the same vein, I love dollhouses. I have dollhouse books and visit the dollhouse museums when they open.

---So in your works are a lot of things that freak you out?

I think I draw things that I love and things that scare me.
Oh, and I'm very afraid of clowns.

----You've had clowns appear in your works as props, right?

I remember that when I was a kid I had a clown doll and it scared me so much that one day I threw it onto the roof. Now that I think about it, doing something like that is much scarier than the doll…(*laugh*)

---Yeah, that might be scarier…

When I was watching the movie Poltergeist and the clown appeared I was impressed how the director was probably doing that on purpose, knowing how scary it would be to so many people. I want to do stuff like that. I actually wanted to become a film director, if I hadn't become a mangaka.

Where do souls come from, where do they go?

---In the past, you've told me it's scary for you to think about the end of the universe.

It is scary! For example, if I was reincarnated (though I don't know if we really do reincarnate) over and over then the earth will eventually end. Planets have life spans too, and when that time comes, there will be nothing left here.

A state of nothingness.

If the earth is gone, then obviously we will be too. The idea of everything disappearing is scary to me. Plus even if I am reincarnated, my mother in this lifetime might not be my mother in the next. Who knows what kind of person I'll be? Thinking about that makes me uneasy.

I also think about where souls come from. I think that if a human body exists but without a soul, then it isn't really alive.

You know how there's technology like cryogenics to keep your body alive into the future? But I don't think that's possible. Because the soul has probably already left the body.

The body might move by orders from the brain, but with just a body, you haven't really come back to life. You need a soul. After thinking about stuff like that, I created a story called *Neji* (*Spiral*).

The Strange Relationship between Master and Servant.

---By the way, I feel that your stories are erotic…

Maybe all writers are perverts? (*laugh*) You think so?

----Well, by erotic I don't mean perverted. It's not that simple. Like the scene where Setsuna and Sara get together, it was so pure that I didn't see it as dirty.

Well, I was very embarrassed as I drew it. (*laugh*)

---I sense a lot of Eros in other parts. For example, how you draw the relationships between the master and servant. Some of your characters are just so devoted in their love.

For stuff like that, the worse it is, the more people like it. A lot of readers thought that Cain and Riff were in love with each other, but I wasn't thinking that at all. Though I can kind of see it now. (*laugh*) That was just a case of me wanting to have the characters do something unexpected that would be memorable to the reader.

And about the master-servant relationship, I'm the type of writer who has to put herself in the shoes of the character. So I always have to think like Cain to be able to write him.

Plus, I like to be taken care of, so I write him thinking that it would be nice if there were someone like this around. Riff is like the mother. So it's a relationship like a mother bird and her chick. I want to be cared for, I want to be spoiled. It's a reflection of my own desires.

So I actually don't put that much importance on conventions of the master-servant relationship.

---I see. I didn't feel like their relationship was homosexual, but the whole notion of someone devoting themselves to someone else is erotic.

My characters are pretty devoted, aren't they? (*laugh*)

 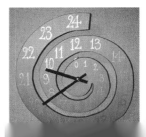

Parts of Kaori Yuki's collection. There's usually a white rose inside the antique birdcage. The Alice clock is something given to her by a fan, and it's always sitting on her desk. The dollhouse is something her sister made for her as a birthday present.

**Come over wearing
your nicest clothes.
And don't forget
your pretty hat.**

Otherwise you can't get crazy stories like that. Like stabbing someone to death or protecting them… Especially to tell the story in only 30 pages.

And for the character to be that loyal, he can't just be hired. There has to be some deep reason. I think humans are sad if they are merely alive. They need a passion and sometimes they will just make something that passion to hold themselves together. Then they become devoted to that. Well, that's what manga is to me, but maybe I'm oversimplifying.

 **People's pasts make
the story go around.**

---I think one of the specialties of your works is that each sub-character has his own story. What's the process for creating each character's story? Do you think of a main theme and then use each character to support that? Or do you have these characters in mind to begin with?

I never think up the theme first, actually. I do start off with "I'd like to create a story like this" and then I create the characters as I go along. As things progress, I'll think "Why is this character acting like this?" And I add, "Oh, because he did stuff like this, he became like that" and in the end I achieve my overall theme. The message doesn't come till the end.

----Do you ever come up with a story just because it will allow you to draw a certain scene?

Yes, that has happened.

 **What I wanted to draw
were bloody Angels.**

----Is there something that you haven't drawn yet that you'd like to?

There's some stories that I used to want to do, but they wouldn't work anymore. Though you'd really see my roots in them.

----Are they stories related to things that you were influenced by at that time?

Yes, they are stories that would make the reader see how much I like American movies. Especially ones about growing up. One story was about three American boys and how they dealt with love. Like the move *Outsider*.

I wanted to make it have multiple parts and follow the characters growing up and all the way to their deaths. I was really excited over that. Now that I think about it I'm not so sure it would work well.

----I heard that Angel Sanctuary is a story you wanted to tell for a long time.

Yes, but not that long.

----Well, with a series as a whole, are there certain stories you want to tell first and the overall theme comes later?

Yes, even in a series the theme comes later. But if you ask me what the theme to *Angel Sanctuary* is, I'll have to answer with "I don't know." (*laugh*)

But what I wanted to create was a complicated world of Angels in love and in a bloody cruel war. So the peaceful parts in the story aren't really the scenes I was looking forward to drawing. Though of course those are needed as the backbone of the story.

----So lately the part you like drawing the most is the messy love drama of Angel Sanctuary?

I do enjoy that. I got really excited when I learned there were classes and ranks for Angels.

----So the story got its start when you learned of the different types of Angels?

Yes, I read a book called *Nocturne*. But there was already a manga that was based on it called *1/2 Moon*.

In that story, a demon Prince and Princess come to earth and eradicate a demon who has possessed an idol singer. Ever since reading that, I wanted to write about Angels and Devils running around Tokyo.

----So was making Setsuna the main character something you thought up later on?

Yes, that came later. I was so happy when I learned they would let me do *Angel Sanctuary*. But I only had a month break before it would start, and I had a lot of color work I needed to get done beforehand. I barely had any time to come up with the new story. But I was really excited as I did it.

As I did it, I realized that this is the kind of story I always wanted to do. Looking back on it, the *Cain* series was kind of constraining. Too many rules because the setting was the human world. But for *Angel Sanctuary*, I was completely free. That's what I like about fantasy. If magic exists, then you can get away with anything.

 What's important is fun.

----When you're creating something, what's most important? Something you can't do without?

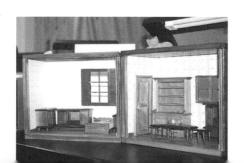

When I want to see a movie, I rent the ones that will make me cry. I want to be moved emotionally. So I like movies where the director is controlling your emotions. I think that's the sign of a real professional. I believe manga should be the same. If you're going to ask someone to read your manga, then you have to entertain them as much as possible. Though sometimes I feel like I'd like to create one that wasn't like that. I want to surprise the reader, even betray them sometimes. That's what I'm thinking when I'm creating my manga.

----Is this desire to entertain connected with your enjoyment of scary stories?

Aren't scary things fun? Of course, I don't draw anything that's so scary it makes the hairs on the back of your neck stand up. I think it would be difficult to create a story so scary that you couldn't sleep at night. A work that represents my feelings on this is *Zankoku na Douwa-tachi* (Cruel Tales). I wanted these stories to have the feeling of a fairytale but also be cruel and scary.

I heard about a story involving the forest of Vlad the Impaler in Transylvania (The Legend of Dracula) and thought it was very interesting. This inspired me in my own stories. This story of the forest was about a man who is walking through

a forest when he notices that there is a strange smell. He looks around and suddenly notices that what he thought were trees all around are actually people who have been impaled on stakes. I changed that story around and used it as the first chapter in *Zankoku na Douwa-tachi*.

----So then, what you want to draw is often not the story but the atmosphere?

Well, something that has only atmosphere isn't interesting to read. You have to express that within the story. That's one reason why I put a lot of effort into drawing costumes. For the dress of the girl who appears in the Count Cain series, I totally ignored the conventional designs of the time. I figured "as long as it looks good." (*laugh*) That may not be realistic, but if you don't try interesting things, then the reader will be bored. You have to be able to please the reader.

 The helpless but beautiful victims.

----Within your works, *Sareki Oukoku* (Pebble Kingdom) seems to stand by itself. Why did you choose the desert as the setting for that one?

I just like the sand, don't you? The feeling when it falls through your fingers…
And I like drawing deserts.

----There's a lot of series that take place in deserts, aren't there? And in ruins too.

Becoming sand and vanishing, the world of those who have perished…

---So not just a desert, but the fact that there used to be something there that perished? You like the idea of that?

Yes. I really think it's cool when I see movies that show buildings in Tokyo buried in sand. But I think *Sareki Oukoku* is the real me. I really like doing fantasy. I create a lot of different things now, but I feel that fantasy is my true calling. I see *Angel Sanctuary* and *Sareki Oukoku* as fantasy.

 A world of only black and white.

----Your art has great contrast; you can really notice the difference between black and white.

That's probably because lately I've been increasing the use of black. Using darker darks and whiter whites. I'm putting more care into using contrasts. For example, if I'm drawing a black person then I make the background completely white. I really like art that's simply black and white. But those drawings take a lot of time and effort, but that's what makes them so great. But unfortunately I don't have the skill and time to do it and my assistants aren't use to doing it either, so we need to use tones. I probably use more tones than most people because I used to look up to that. You know how there's some mangaka who only do about 10 pages per month? Well, they put so much care and detail into every page. I'm in a different situation and can't compare, but because I admired that art I started using lots of tones.

Sensual lines, human expressions

----Anything else you put care into?

In terms of art, I try to work on movement and humanism. Earlier we talked about eroticism, so I might be repeating myself, but I try to draw

Kaori Yuki's World part 1

Admiration for Western Films

The roots of Kaori Yuki's works can be traced to her love for western movies.

It was in high school when I got into movies, influenced by a friend who loved western movies and music. At one point in my life, I would watch up to three a day… And of course I listened to a lot of western music. At this time I wasn't interested in Japanese music at all. My favorite artists were the Thompson Twins, Cure, and Culture Club among others. Though I currently don't listen to any western music at all.

Cruel Tales

Comics list

**I'll bring out a special tea
I've been saving.
And buttered bread too.**

human lines. Some people draw sexy skin that looks like it's from an anime but I don't like that too much because it lacks bone structure. I really try to go for natural flesh feeling.

----Like making it look fresh?

Yeah, I just get a better feeling with that. Though in terms of eroticism, I seldom use nudity to express this.

----That's true, you don't draw much nudity.

So how do I express sexiness? In things like fingers that brush away hair while in an embrace, or in the folds of clothes. You can't see it, but I like to draw scenes where someone can say, "Hey, where's he putting his hand?!" I guess that's what you'd call fan service, but I think of it as entertainment.

In the latest chapter I did, there's a scene where Kurai is attacked, but you can't really tell anything from just the dialog. So as I was drawing it I thought, "This isn't erotic at all." So I tossed out what I had and started over from the beginning and went even further with it. I redo things like that two or three times every chapter.

 Fan service is the essence of drama.

----Your works have many attractive men, but what's something you put care in for expressing a man's sexiness?

A man's sexiness?! (*laugh*) First is the eyes. Then, it can't be a man that looks like a woman. I want it to be a man in disposition and bone structure. And also, fingers. A man's fingers should be long and cool looking. I really try to go for sexy fingers. Not that I'm very successful.

And this applies to women too, but I put a lot of care in the hair.

---The hair?

I actually plan things based on the character's hair type. (*laugh*) Rough hair, soft hair, not that I express it very well in my art… In the latest chapter, I drew Astaroth, whose hair I decided would be like faded and damaged hair.

----Can't they protect their hair with magic….? (*laugh*)

I like damaged hair. Because I like the rock star hair. (*laugh*)

----It would be funny if there was a shower scene for every character and they each had different shampoo. (*laugh*)

And what kind of bubble bath they use. (*laugh*)

----Oh yeah, there was a bath scene with Rosiel.

That was a fan service scene. At first that scene was just him talking in his office. But then I said "This is no good! Let's change it to a bath scene! Plus it's a bath of roses!" (*laugh*)

----Total fan service! (*laughs*)

There was also a similar dizzying scene where Katan gets his body back and is reunited with Rosiel who keeps asking him, "Am I beautiful?" But I didn't plan it like that at first. But I figured I had to make it more dramatic, make the readers' heads spin. While I thought about that I suddenly realized "Oh yeah!! He's a freak!" (*laugh*) Since Rosiel seems to ask "Am I beautiful?" no matter what the situation, I figured he would also ask it then.

Plus, he didn't make a happy face the moment they were reunited. I figured that at first he would hold it in and then the emotions would pour and then it would be a "storm of love!!" (*laugh*)

----Do you think of things like that alone at night? (*laugh*)

I'm happy when I do. I think, "This is perfect!" But when I have to draw it I get really embarrassed. (*laugh*)

I'll call my editor and say, "I'm too embarrassed to draw this…" and then he'll say, "It's good!" and then I can finally do it.

----The unique worldview in the Kaori Yuki universe is created by each and every one of these scenes, isn't it?

I don't like it when my art is called perverted, but I do take it as a compliment when people say it's erotic. (*laugh*) Though I don't want that to be the only focus, I want the reader to see there's a story too.

(May 23, 1997, At Yuki-sensei's work place)

Kaori Yuki's World part 2

Enjoying movies alone

My love of movies escalated, and after I entered a trade school, I'd watch three movies on video everyday. I'd also see David Lynch movies and ones like *My Life as a Dog* alone in the movie theater. My favorite movies are ones that make me cry. After seeing a good movie I think about creating a manga that has the same quality. I want to pass on the emotions I get from the movies on to my readers.

Mark of the Red Lamb

Illustration Records

Postscript

In my tenth year as a mangaka, my first art book… How did you like it? Not sure if it's early or late, but it feels like every step I've made has been worth it.

Now, the title Angel Cage means a birdcage for Angels. I had thought up other titles, but this one seemed to match the idea of restraint and confinement seen in my manga.

However…looking back at my work like this makes me feel a little embarrassed. I still have a long way to go before I reach my goal, in many ways. And it's a mystery whether it's something I'll ever be able to reach…

And finally, I'd like to thank from the bottom of my heart everyone who helped me with this art book, the designers, my assistants who helped me, my family and all of you fans. No, seriously.

June 1997
Kaori Yuki

由貴香織里

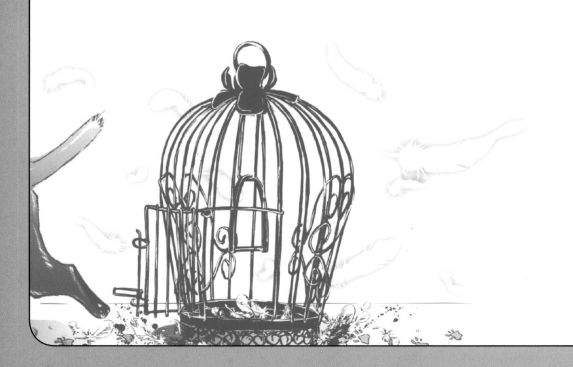

Contents

The Art of Angel Sanctuary

ANGEL CAGE

The Art of Angel Sanctuary
ART BY KAORI YUKI

ORIGINAL JAPANESE EDITION

Design/Mugen Kanzaki
Editor/Megumi Ouchi (Studio Amu)

English Edition

English Adaptation/Alexis Kirsch
Layout/Yukiko Whitley
Editor/Pancha Diaz

Managing Editor/Masumi Washington
Director of Production/Noboru Watanabe
Vice President of Publishing/Alvin Lu
Sr. Director of Acquisitions/Rika Inouye
Vice President of Sales & Marketing/Liza Coppola
Publisher/Hyoe Narita

Printed in China

Published by VIZ Media, LLC
P.O. Box 77010
San Francisco, CA 94107

First printing, August 2005

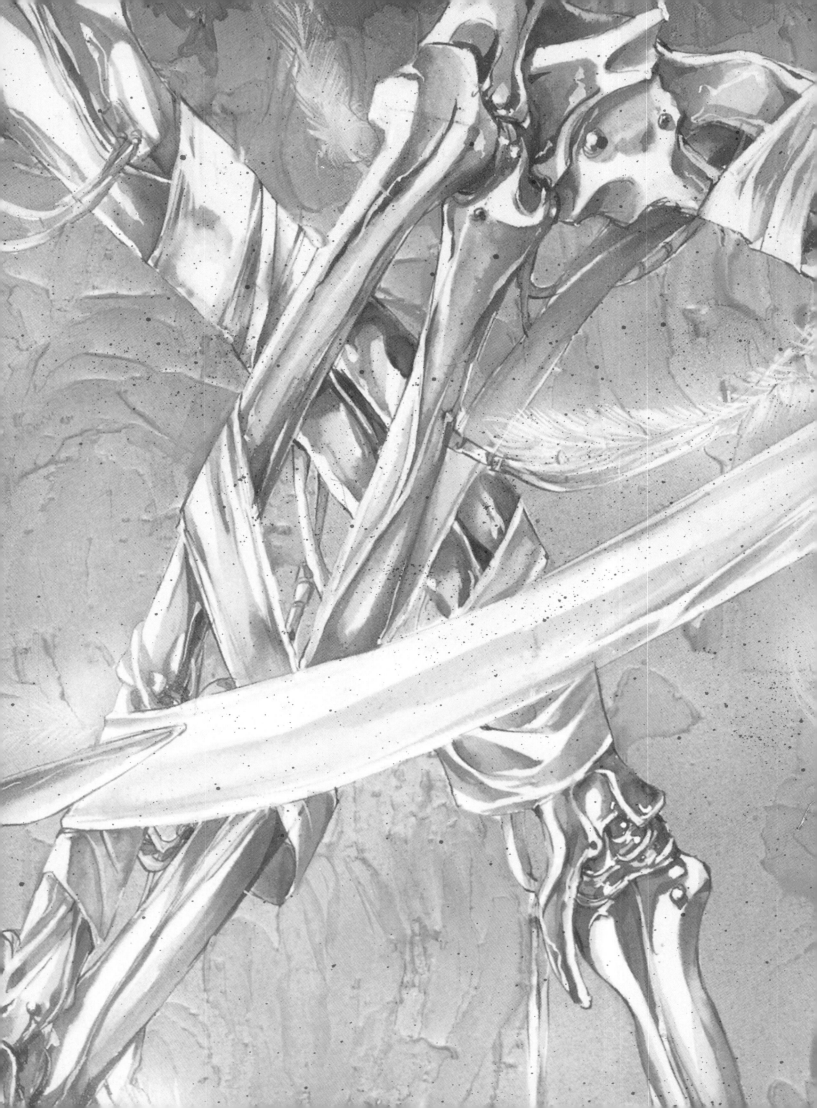